Sketching
People
&Places *In All Mediums*

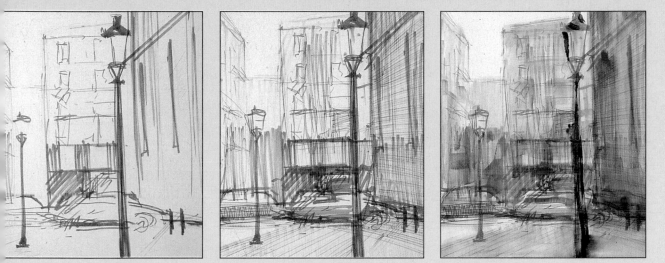

OSE M. PARRAMON

Watson-Guptill Publications/New York

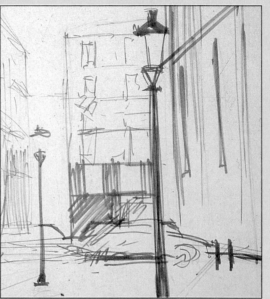

Copyright © 1991 by Parramón Ediciones, S.A.

First published in 1991 in the United States by Watson-Guptill
Publications, a division of BPI Communications, Inc.,
1515 Broadway, New York, New York 10036.

Library of Congress Cataloging-in-Publication Data

Parramón, José María.
 [Dibujando pintando apuntes. English]
 Sketching people and places in all mediums / José M. Parramón.
 p. cm.—(Watson-Guptill painting library)
 Translation of: Dibujando pintando apuntes.
 ISBN: 0-8230-4852-7
 1. Drawing—Technique. 2. Humans in art. 3. Animals in art.
 4. Landscape in art. I. Title. II. Series.
 NC730.P28313 1991
 741.2—dc20 91-10273
 CIP

Manufactured in Spain
Legal Deposit: B-11.083-91

1 2 3 4 5 6 7 / 97 96 95 94 93 92 91

Sketching
People
&Places *In All Mediums*

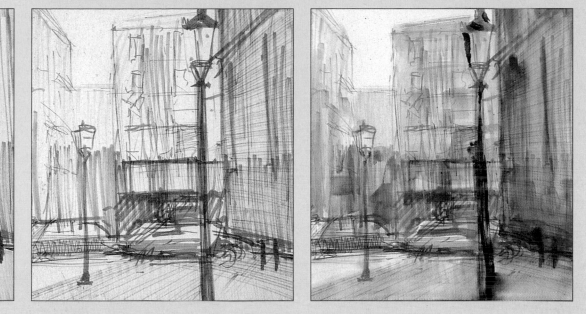

The Watson-Guptill Painting Library is a series of books designed to help artists improve their work by studying the methods of other, leading professional artists. Each book demonstrates techniques and procedures for painting such subjects as landscapes, seascapes, still lifes, figures, and portraits in one of a number of popular mediums including watercolor, acrylic, pastel, colored pencil, and oil.

What is really extraordinary about the Watson-Guptill Painting Library is that each technique is explained and illustrated line by line, brushstroke by brushstroke, step by step. Each demonstration is accompanied by dozens of photographs taken while the artist was painting the picture. The artists discuss what influences their choice of subject and they illustrate their approaches to composition, color, and light and shadow.

In this book, we will explore all the possibilities of sketching. You will learn how to master sketching techniques by studying works by great artists, including van Gogh and Picasso. This book will show you how to achieve the ambiance of a cityscape; capture the liveliness and grace of ducks in a quick sketch; and render an evocative abstract landscape.

I personally directed this work with a team I am proud of, and I honestly believe that this series can really teach you how to paint.

José M. Parramón
Watson-Guptill Painting Library

Sketches, rough drafts, studies...

Very often we visit exhibitions of paintings, generally those of the painters we like. If we consider an image from one of these works, we might imagine that these paintings were created "out of nowhere"; in other words, from the skill and the talent of the painter, from his "inspiration," or from the "beauty" of the theme he or she chose.

Luckily, we have all had the opportunity to walk around in a painter's studio, even if it was our own. We always find piles of paper, notebooks full of lines and stains, piles of sketches. These drawings, sometimes very exact, other times confused, seem to be little works of art, the painter's sensitive efforts, where the essence of the artist's process occurs, as can be seen in a specific painting and in the long path of a life dedicated to painting.

Probably, we all have an intuitive idea of what a sketch is. If we are shown several drawings or paintings, we can distinguish the "definitive" works from the sketches, color studies, and rough studies. But, how do we define these works? By their appearance. Sketches are usually reduced in size and are done quickly; they have an "unfinished" look, although they are "completed" (for example, a background may be left out, the model could be sitting on nothing in particular, and so on). But above all, the sketch contains just enough of all the necessary ingredients. This is the important thing. The sketch gives us information on the theme, without exaggerating or detailing, it's basic, complete. The sketch must include the essence of the theme, but—wait!: the "essential" and the "fundamental" of a theme depends, ultimately, on the painter. There is no general norm. You could say: "The most important thing is form, construction," and I could answer: "No, the most

Fig. 1. Vincent van Go (1853-1890), *Two Se Portraits with Detail Stu* Rijksmuseum Van Go Amsterdam. This pag which is taken from a no book of sketches by v Gogh, is a typical exam of a sketch: several ov all or partial studies of t same subject, mixed gether and overlapping

Fig. 2. Francesc Ser *Nude.* This nude is a sket not a finished work. C serve the simplicity of t tones; how the artist ach ves the shape and volume of the body by ing two tones. The ske has been drawn with ch to indicate light and s de, and then retouch with small gouache bru strokes.

1 2

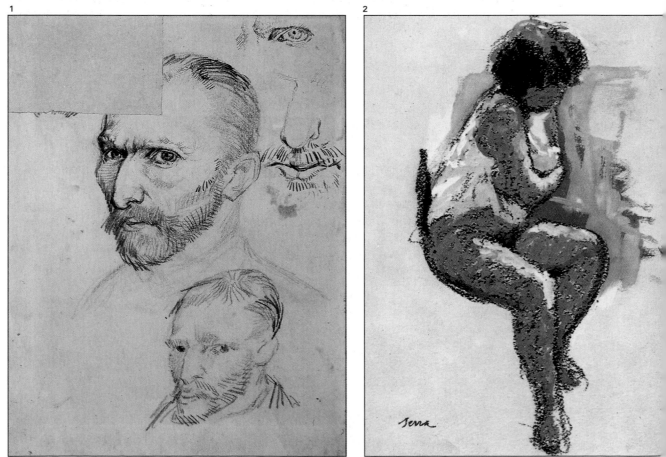

important thing is the illumination of the darks and lights.'' We would both be right.

The sketch contains an essence that most closely relates to the painter's intention. The sketch conveys not only the artist's study of light and shade, shape, and color; it conveys the spirit of a finished piece, the reason for drawing or painting a particular subject in the first place. In the following introduction we are going to review three basic functions of the sketch:

1) Artists make preliminary sketches of a subject in order to really understand that subject.

2) Artists sketch studies to warm up, to loosen up their limbs, and to free their thoughts.

3) Sketches are made to lay the groundwork, in the studio, for the execution of a finished piece.

I will not comment here on each function, as this will be done later on. I should, however, say that the painters who have so kindly offered to supply sketches for this step-by-step book, have done so with no specific purpose in mind, as that is something individuals must invent for themselves.

Sketches may represent the overall line or shape of a subject, the colors that define the subject, contrasts of light and shade, or the schematic construction. Whatever its purpose, a sketch should be done quickly. No time should be spent on adornments or retouching; instead one should do another sketch.

Look carefully at the sketches on these pages. Read the captions that accompany them. The captions stress what you should focus on in order to get the most out of your observations.

Fig. 3. Michelangelo (1475—1564), *Study of Adam*. British Museum, London. This study corresponds to one of the best-known figures in the history of art: the Adam of the Sistine Chapel. Michelangelo made this sketch from life; he used it as a basis for a fresco, without painting the entire form, just the part that most interested him.

Fig. 4. Auguste Rodin (1840-1917), *Sapphic Couple*. Rodin Museum, Paris. This magnificent sculptor, considered a pre-impressionist, was a prolific draftsman who made hundreds of studies and sketches for his works. This is not a preliminary sketch of any particular work, but it does convey a strong sense of sensuality, which is one of the characteristics of Rodin's work. Watercolor, with its qualities of freshness and transparency, compliments the beauty and sensitivity of the shapes.

4

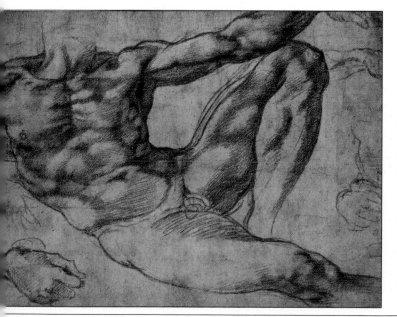

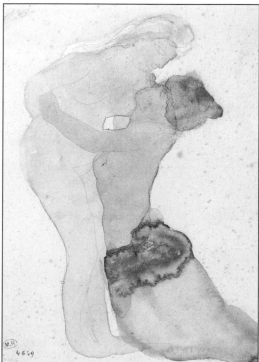

Warm-up exercises

How can we best explain that painters must learn to free their minds and concentrate solely on the subject they wish to sketch? When I asked myself this question, I immediately thought of a great example. We all know that athletes do warm-up and maintenance exercises every day, to prepare both mind and body, so as not to lose agility, speed, and strength. Painters must also warm up, immerse themselves in the subject, and develop a rhythm with these initial exercises.

These warm-up exercises are the sketches you practice before beginning to paint, simply in order to concentrate. While warming up, you may begin working without realizing you are doing so and this makes beginning to paint easier (because painting is difficult, as you already know).

Sketches can be done in many ways and with an endless variety of subjects. You can sketch in any setting, with whatever tools you happen to have with you. If you are outdoors, you can draw with a simple soft pencil and a small notepad. You can sketch people on the street, bustling on their way to work; a father and child at the park, feeding the pigeons; or a beautiful sunset at the end of the day.

If you visit an art school or attend a workshop, you will see artists sketching from live models. The models can assume either fixed poses, for a prescribed length of time, or moving poses, where the model moves about naturally, and the point is to capture a single motion or expression. Figure 7 serves as an example of this type of sketch.

There are still many other ways of doing sketches, and of training the hand, sight, and mind. Another source of inspiration can be your television screen. Seated in front of the television with pencil and paper, you can draw the movements and shapes of any number of subjects, be it the stage set of a drama, a player in a football game, or a dancer in motion. The sketch of the flamenco dancer below, by Vicenç Ballestar, was rendered while he was watching a dance competition. The point is take advantage of potential resources all around you.

Remember that we make these warm-up sketches for two reasons. The first is to experiment with various techniques and to try new methods. We also want to test different types of paper to obtain unique effects.

Naturally, the objective must be precise. If we wish to capture an object in motion, the basic outline that delineates it must be definite. If the subject was chosen because you want to study the contrast between

Fig. 5. Raimond Vayre sketched this colorful landscape of a small village. Decide on the composition, try staining, and experiment with mixing and watercolor. Try everything, loosen up your hand, and you may achieve sketches as colorful as this one.

Fig. 6. Vicenç Ballestar drew this lively sketch of movement and gesture from the television screen. He obtains rich lines by using a lead pencil.

5

6

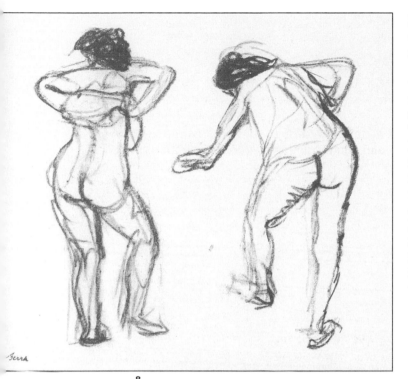

lights and shadows, the whole sketch should consist of two or three tonal patches, and so on.

Another area of sketching we can explore with this exercise is rendering with a simple technique using graphite, charcoal, or reed and ink. Start by drawing lines and points. Then, to get numerous effects, practice gently smudging the marks you made with your finger. A line can vary in thickness depending on the amount of pressure you apply to the stick of charcoal. Work to develop the correct outline, but don't erase lines you have already drawn. Add more strokes if necessary, until you find yourself becoming satisfied with your work. Then try drawing only with patches of color. Experiment with everything.

8

g. 7. Francesc Serra, *ketches*. These are some arm-up sketches that the ainter made in order to re-ain nimble-handed. The ovement of the model as e undresses is suggest-d by the ''search lines,'' uick lines that define the rm without shaping it.

g. 8. Vincent van Gogh, *ater Lilies*. Rijksmuseum an Gogh, Amsterdam. an Gogh drew endless ketches, which reveal a uly impressive search for xpression. We should not e surprised therefore by e extraordinary power of e brushwork in his oil aintings.

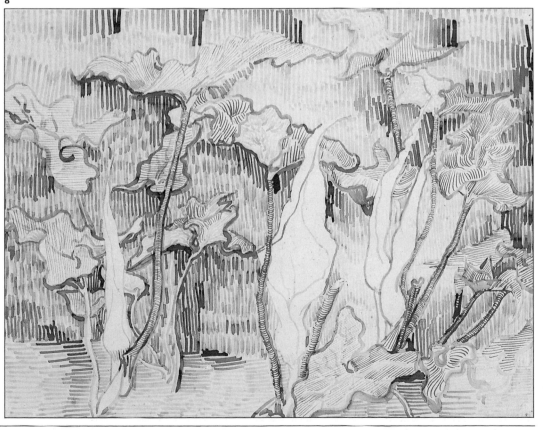

Preliminary sketch of a subject (I)

Occasionally, the painter decides to paint a series of pictures based on a single subject. The subject may be a landscape, if he has visited a new, unknown area; a portrait because he has decided to capture rapid movement; or a still life so that he may study a composition of inanimate objects.

There is an infinite number of ways to approach one single subject. And an artist may render different subjects using methods that intrinsically vary. An artist who has spent a long time working on studio subjects, including portraits and still lifes, may encounter difficulties when confronted by a land-scape. The dimensions of the subject have changed: A landscape is an undefined, unlimited subject. The artist can find it enormous and overwhelming in comparison to a studio still life subject. Light, which is an intrinsic part of the motif, cannot be controlled outdoors as in the studio. Artists must be flexible.

Every new subject demands a fresh outlook and a capacity to see and represent subjects in a distinct way that is the best approximation, the best synthesis of the model. Flexibility is the key because the world contains an infinite assortment of

Figs. 9. and 10. Sketche made by Raimond Vayre da (Barcelona, 1962) i Segovia, in the Castillia plateau. We should con pare these sketches wit those on the next pag (figs. 11 and 12) that de pict a very different land scape subject from this fla region. Even though th painter uses the same lin technique, differences ex ist in the format he ha chosen. In this case, Vayr da draws on rectangula paper, expressing the ho rizontal nature, the chara teristic flatness of the sul ject, right from the star These sketches are part a long series, two more which appear on page 1

9

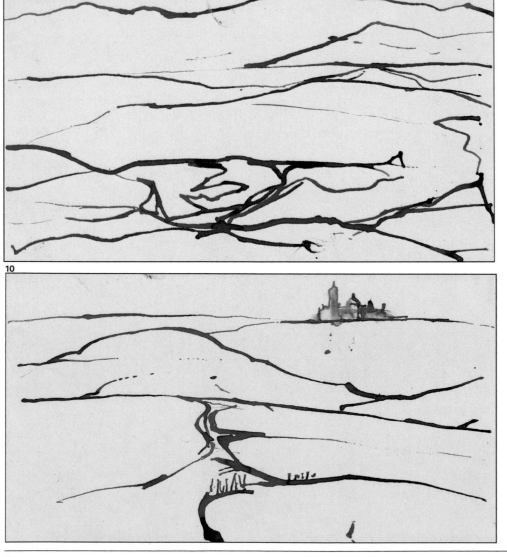

10

Figs. 11 and 12. These sketch were also drawn by Raimond Vayr da, but this time the setting is a ve wet, mountainous northern are We can detect the same persona ty in both sketches, but the artist attitude has changed. This is wl we want to stress that the idea studying every subject throug sketches is a fantastic way of s gling out the essence of a subje along with experimenting with tl techniques necessary to best e press a subject. Observe how t two sketches differ and how th are similar: for example, unlike t sketches on the previous pag these sketches are from an aer view, and there is no horizon line visible sky.

hapes—there is an obvious difference be-
ween a figure and a landscape. Also, light-
ng and color ranges vary from situation to
tuation. Lines don't always accurately
epresent a subject and the artist may have
o use patches of color, because one tech-
ique may more accurately represent the
ibject than the next.

Most of the painters I know tell me that
aking sketches is a magnificent method for
etting to know a subject well. Sketching
ables artists to choose the most interest-
ig or characteristic feature and find the
pe of line, color, or brushstroke that best
xpresses the significance of the subject for
e painter. I must stress, however, that it
not a matter of altering personal style.
rtists must approach every subject sincerely
very time they paint, and should not de-
lop a narrow-minded view or a false idea
f what their personal style is.

I think that all these questions, which are
ither difficult to understand if you are not
onstantly painting, can be made clearer by
eans of an example. To illustrate how one
tist can adapt his technique to different
bjects, I have chosen two sets of sketches
ade by a good friend of mine. These
etches express his impressions of two
fferent subjects and we can compare

them easily because both are landscapes.

The painter, Raimond Vayreda, went to
work for a month during the summer to
Castille, Segovia, to be exact. The charac-
teristic flat terrain of that area is seen in
figures 9 and 10. Six months later he was
painting in Catalonia, a wet, mountainous
area to the north of the Iberian peninsula,
and figures 11 and 12 illustrate his impres-
sions of that area. We shall see how the
painter interprets the differences between his
subjects.

12

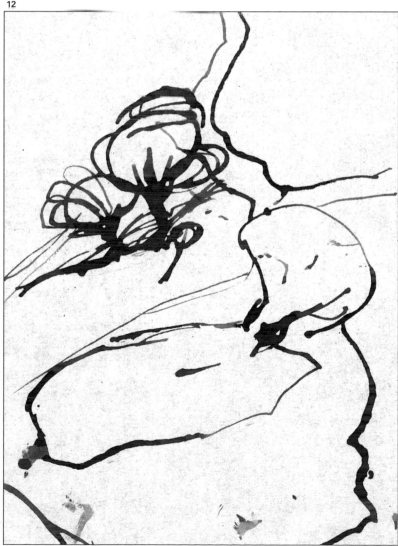

Preliminary sketch of a subject (II)

Let us compare the sketches on these two pages. We need only a reference concerning the settings of these sketches: one set in a flat, fairly arid area in hot weather (figs. 13 and 14), and the other in wet, mountainous, woody terrain (figs. 15 to 17).

How has the painter represented the differences between the landscapes? He has done so on many levels, beginning with understanding his composition and ending with technique.

In the first situation, the painter is faced with a flat subject. He chooses wide sheets of paper and sketches horizontal compositions. In the second set of sketches, he is surrounded by mountains with winding paths that branch out. He chooses rectangular and square pieces of paper.

The horizontal lines of the fields of wheat are flat in comparison with the more rounded shapes of the trees, woods, and hills. Vayreda has used different techniques to represent the identity of the different geographic regions. The stark lines in the first set of sketches have been exchanged for volumes, and the broken strokes replaced with wavy shapes.

And consider the light: There is strong sunlight in the dry, hot area. Consequently, there are hardly any details in figures 13

and 14, only stark lines and sharply contrasting patches of color. Figures 15, 16, and 17 show spring in the mountains; the sky clouds over, and the round spheres of the treetops affect the light. Volume is expressed in value gradations and markings; each tree has its own distinct shape and occupies a clear, distinct place. The small fields are laid out following wavy contours, and the branches, paths, and fields are rounded shapes that ultimately build up the landscape like pieces fitting together in a jigsaw puzzle.

The synthesis of the landscape is different in each case. In figures 13 and 14, where the painter is familiar with the Segovia countryside, three or four lines are enough to

Figs. 13 and 14. Raimo Vayreda, sketches of S govia. The painter co tinues to use rectangu paper, and works in a s gle color, in ink or liqu watercolor. He express the powerful sunlight, t loneliness of the moo and the absence of ve tation, with the excepti of the river banks. He m also convey the broadne of the view and the i mense depth that we s at a single glance. Co pare all this with those the next page (figs. 15, and 17).

13

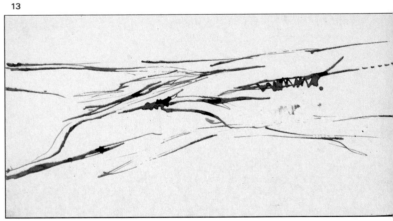

14

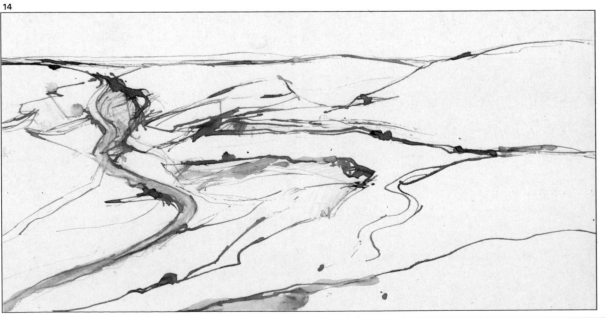

epict the essence. The depth of view and
ne broad horizon are distinctly executed,
nd the brushstrokes, although short, suffi-
ently explain the small breaks, changes,
nd values of the landscape.

Differences between the sketches become
ven more evident when we analyze the tech-
iques Vayreda used. In the pictures on the
ft, he used liquid watercolor or ink, us-
ng a thick reed to apply the color to the
aper. Below, he has experimented with and
ombined several media, including pencils,
raphite, watercolor, ink, and pastel. He
ses many types of markings—lines, dots,
umping, and both wet and dry patches—to
t himself be carried away by the complex-

ity of the landscape. He adds color as he
progresses, and each blue, each green, is
necessary for explaining his vision.

I think it is now sufficiently clear that
each subject is to be approached individu-
ally. You must know a subject well to be
able to paint it without overdoing it. The
painter who has lent us these sketches, Rai-
mond Vayreda, remarks, "You must get to
know each landscape, feel it as if it were
natural to you, and know how to look at it."

The sketch is the best means of getting
to know a subject. At the same time, you
can acquire a more nimble hand by ex-
perimenting with and learning new methods
and materials.

Figs. 15 to 17. More
sketches by Vayreda. Ob-
serve how the artist sear-
ches out patches of color,
which range from soft and
subtle to hard and sharply
contrasting. By defining
these colors he explains
the landscape. Every land-
scape has its own identity,
thanks to the landmarks
nature provides. Artists
find their own subjects de-
pending on what they find
most important in the land-
scape: a dry landscape
(broken and geological), a
wet landscape (lush and
colorful), or an urban land-
scape (geometric, light and
shade, perspective).

17

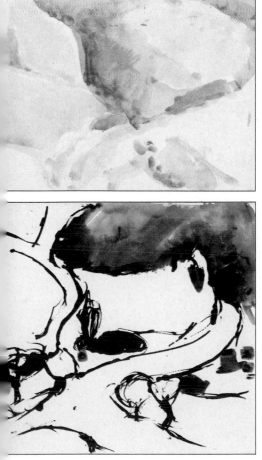

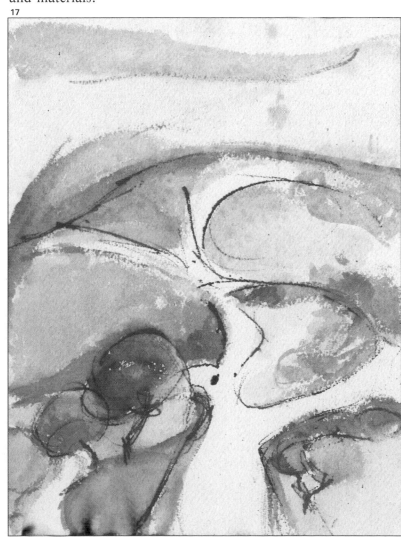

Studies: sketching for composition

There is a third type of sketch, called a study. Studies are sketches or drawings whose purpose is to form the basis for a definitive work. Studies are not precisely the same thing as typical sketches, which an artist makes without any concrete objective. Nevertheless, both types fall into the category of sketching: they must include only the essentials, they must respond to a very clear idea, and they are not definitive works.

Through studies, artists can initially try out what they would like to paint as a formed picture. Occasionally, painters practically finish the work in the sketch. In most cases, however, the artist studies only certain questions that affect the final result: the composition, the format, and the framing of the subject. Perhaps the artist may also study certain shapes, the type of lighting, the color range, and so on.

Here on these two pages are reproductions of some studies by Pablo Picasso (1881-1973). Picasso made these sketches in preparation for one of his first pictures, entitled *Life*. The artist was searching for the way to express the subject of life; he wanted

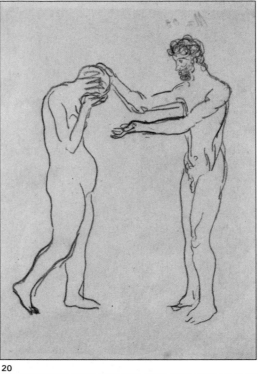

19

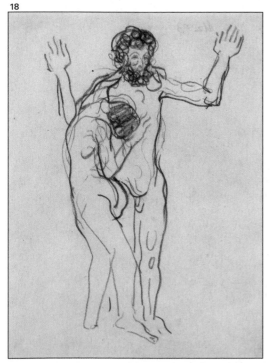

18

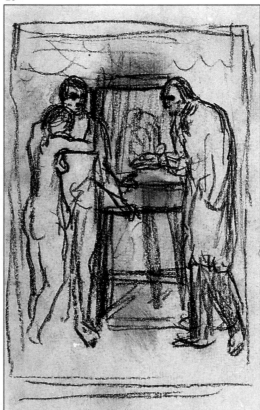

20

Figs. 18 to 22. Pablo Picasso, studies for *Life*. Picasso Museum, Barcelona. During the early years his career, Picasso experimented with compositions as ambitious "Life." He was in what called his "Blue" period not only because of the colors he used—general cool colors—but also because he would often use melancholy and emotionally distant figures for subjects, surrounded few objects. His work evolved into pictures great austerity. The studies clearly explain intention; he sought to express the contents of the subject through the relationships between the figures. To do this, looked for a way to combine the figures, the postures, and their relationships: close or separated, embrace or conflicting two or three figures, or women, with or without a background. Through these attempts, he sought the composition.

build up an allegory of life—a picture ntaining several meanings.

He began by staining the papers and rawing figures on each sheet. He then experimented with changing the relationship etween the figures, with the number of gures, and even with the sex of the figures, ntil he discovered a composition he found leasing. An easel appears in the studies in gures 20 and 22, but it is left out in the final picture. Also, if you look at the final result in figure 23, you will see that there are two themes within the whole, as if the figures that appear in the foreground were also the models for the canvases within the picture's background. What do we wish to stress here? That these studies are intended to clarify the composition of the final picture, and also help the artist understand the subject or contents of the whole.

Fig. 23. Pablo Picasso, *Life*. The Cleveland Museum of Art, Ohio. This is the picture that Picasso finally painted based on earlier sketches. Compare the results with the earlier studies, and try to discover the changes and why they were made. The mother and child on the right of the painting seem to be the ultimate expression of life.

23

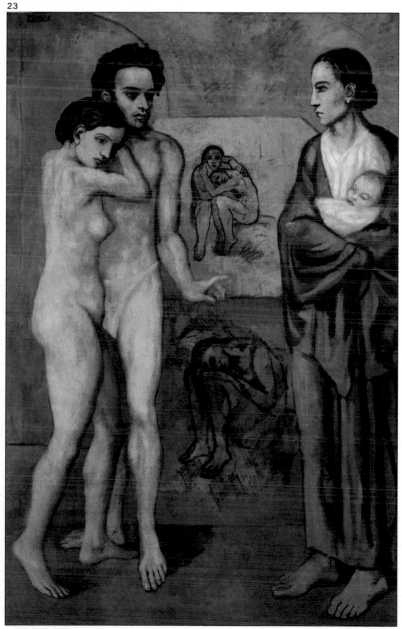

13

Studies: sketching to perfect details

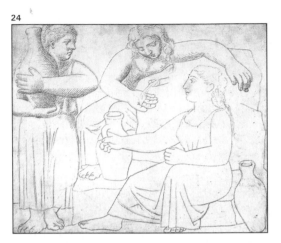

24

Of course there are additional reasons to sketch; we do not always sketch only to clarify the composition and the contents of a painting. Picasso painted another picture, some twenty years after he painted *Life*, entitled *Three Women at the Spring*. On this page are several studies he made in preparation for the final painting.

There are also some composition studies for this work, and one of these is the sketch pictured in figure 24. Observe how the study, which is also a study in drawing, has a horizontal composition while the final picture is vertical. (There also exists a vertical study, which Picasso must have preferred.)

Artists often do studies of particular details, the shape of the hands in the case of this work. Picasso drew the hands on a piece of paper before painting them into the pic-

ture. Many studies of specific shapes can be found in Picasso's work and in the work of many other painters. Remember that it is advisable to get to know a shape and be able to represent it accurately before attempting to produce a definitive painting, especially if it is a difficult shape such as a hand or face.

I advise all artists to take a small sketchpad and draw a schematic layout of the objects they wish to depict before starting to paint any picture. Decide where the shapes are to be placed, what space they are going to occupy, and what empty space will be left over. Make several sketches. Then choose the one that seems the best, the most interesting. This is the first step toward making final paintings easier. Use lines or patches, but simple ones—gather the objects in schematic groups using shapes like triangles and circles—and place these groups in a box to represent the shape of the paper or canvas. This is a basic and very impor-

26

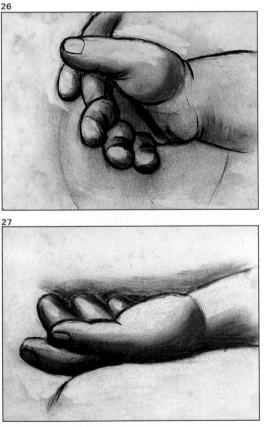

25

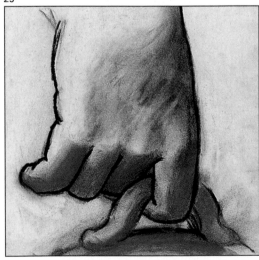

27

Fig. 24. Pablo Picass study for *Three Women the Spring*. Picasso Mus um, Paris. This is a stu in composition, a speci and well-worked drawir in which the artist decid practically everything will define in the final wo It is, however, horizont while the final picture vertical.

Figs. 25 to 27. Studi for *Three Women at t Spring*, by Pablo Picass Picasso Museum, Par Here are studies of cert shapes that require a curate definition. The ar closely observes the po tion of the hands wh they are holding an obje when they are gently re ing. Remember that i important to have a go command of drawing pa cular shapes like the ha Remember also how i portant it is to study ye overall composition, in der to decide where place figures.

tant exercise. A friend of mine, Teresa Llacer, advises her painting students to take a small piece of paper or cardboard, and use a thick brush or pencil, because in this way they cannot include the details even if they want to.

Do not believe that with one good sketch, or two, or even ten good sketches, the picture will be solved. When you are faced with interpreting and rendering a picture, there are always problems to be resolved. If you attempt—and please do—to paint a picture from a sketch, you will immediately realize that because the size of your surface has changed, a small error in the sketch is suddenly magnified in the painting.

It is necessary to sketch, but remember that sketching is not picture painting.

28

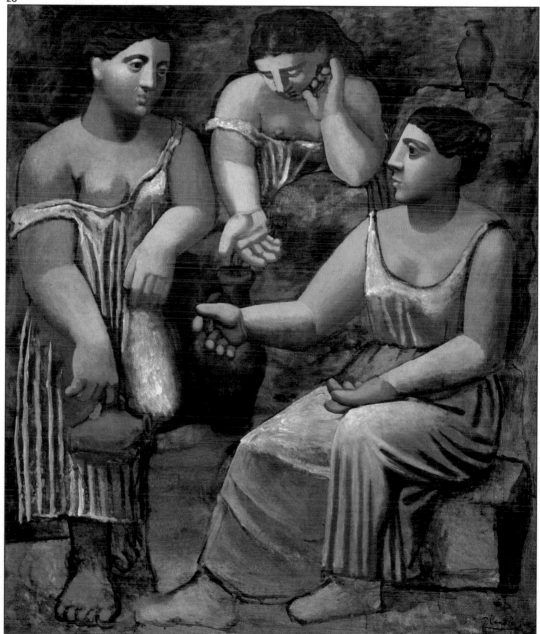

28. Pablo Picasso, *ee Women at the ing*. The Museum of Jern Art, New York. I Jld like to underline the ortance of working out tches and studies be beginning to paint. en we look at a picture, see it as an end unto it-, although this is not ally the case. A great k of art is the result of s, changes, reinterpre-ons, and synthesis of pes. Sketches and lies are the vehicles of process.
you wish to paint a iplex work, remember the results will be suc-sful only if the figures he figure) are well situ-l on the paper. Keep in J the space that sur-ds the figures. Experi-it and draw many ches. Practice drawing nes and heads. Van th said, ''Drawing ches, for me, is like ing, and later reaping, ures.''

How to find a subject

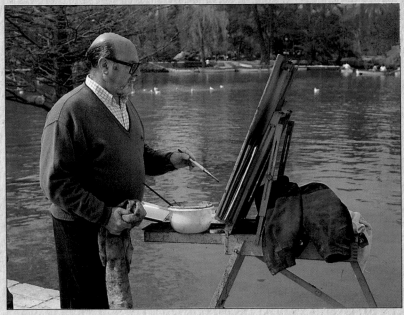

Fig. 29. Here is Vicenç Ballestar at work during a sketching session; the artist loves working outdoors. Ballestar believes that sketches, in addition to being a method of study, are intrinsically valuable.

Vicenç Ballestar, a professional painter, radiates enthusiasm when he discusses his work. Today, a sunlit gentle spring morning, he will go outside to make some sketches, and he is delighted to have our company.

Ballestar tells us that any motif, however insignificant and ordinary it may appear, can be the subject of a work of art. Perfect subjects surround us—on the street, in a park, at the zoo. Artists who study everyday life constantly will find new and exciting subjects. Ballestar has a discerning eye. He combines his artistic discrimination with technique and skill, and this enables him to capture fascinating subjects in his work.

There are unlimited opportunities for finding subjects, and once you realize that a good sketch can be completed in less than fifteen minutes, you can appreciate the amount of work that can be done in a single sketching session.

Sketching should be spontaneous, carefree, and entertaining. Again, sketching is an excellent way to understand your subject, and to prepare yourself for starting to paint a final work. Ballestar is accustomed to sketching in public, but although he is an experienced painter, he admits feeling a little embarrassed when peo-ple observe him working. His jovial, outgoing nature has helped him overcome this sensitivity, and he takes advantage of every opportunity to study new subjects.

Today Ballestar will demonstrate several techniques. He has brought along his basic equipment: a mechanical pencil, some pastels, an eraser, and his sketchpad with $14 \times 20''$ (35×50 cm) medium-weight sheets. In addition, he has $9 \times 12''$ (24×32 cm) 140 lb. (300 gr) watercolor paper, a wooden board, a rag, a plastic water holder, and his easel box that holds assorted brushes and watercolors.

We will observe an entire session during which Ballestar will use wet and dry mediums, graphite, pastels, and watercolors. With all these materials, we have set off for the park, where we will certainly find fascinating subjects to sketch.

30

Fig. 30. Here are the materials Ballestar will use to make the sketches on the following pages. Each tool offers different possibilities, and you should become familiar with all of these materials. By being thoroughly familiar with a variety of tools and techniques you will know, for example, that you can obtain a grainy effect with graphite or lead pencil, while pastels and watercolors can produce more fluid lines.

The work of Vicenç Ballestar

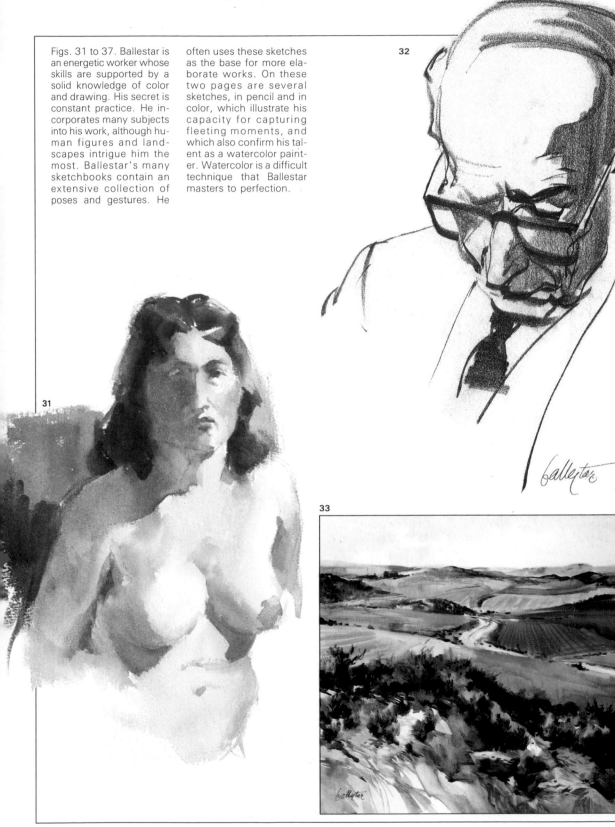

Figs. 31 to 37. Ballestar is an energetic worker whose skills are supported by a solid knowledge of color and drawing. His secret is constant practice. He incorporates many subjects into his work, although human figures and landscapes intrigue him the most. Ballestar's many sketchbooks contain an extensive collection of poses and gestures. He often uses these sketches as the base for more elaborate works. On these two pages are several sketches, in pencil and in color, which illustrate his capacity for capturing fleeting moments, and which also confirm his talent as a watercolor painter. Watercolor is a difficult technique that Ballestar masters to perfection.

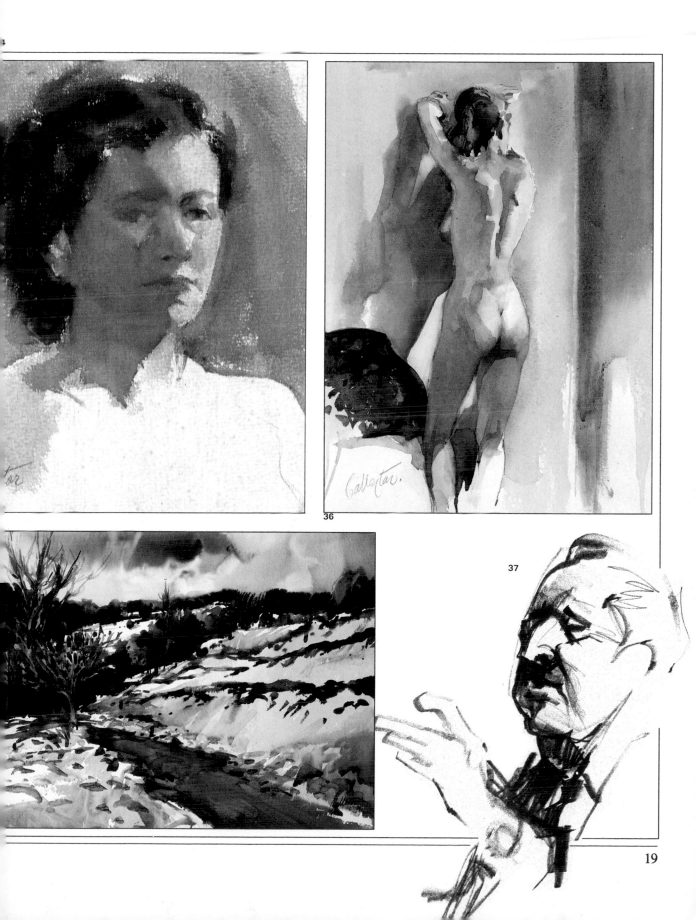

36

37

A tonal drawing

38

After walking around in the park, Ballestar chooses a subject. The photograph in figure 38 shows a wide-angle view of the spot he has decided to sketch. The bandstand on the left, with the curtain of vegetation in the background, provides an interesting motif.

Ballestar establishes his composition with several horizontal and vertical lines. He uses a mechanical lead pencil; pencils are an excellent drawing medium because of the values and the richness of expression you can obtain using them. Ballestar begins to define several figures in the foreground. He indicates the background area with wide, regular lines and adds shadows with fine, irregular lines. These lines create contrast with the straight, more-structured lines that

Fig. 38. A visit to the park can surprise you with an unexpected motif such as the bandstand in the photograph.

Figs. 39 and 40. Ballestar uses a graphite pencil to achieve a variety of effects. The tip of the pencil creates a fine line, whereas with the flat side of the pencil one can rapidly cover large areas gray. Interesting results can also be obtained by understanding and exploiting the grain of your paper. Ballestar feels that this medium gives him as much versatility as painting.

39

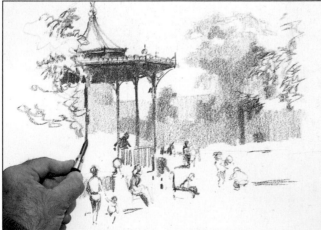

40

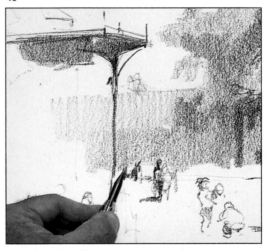

41

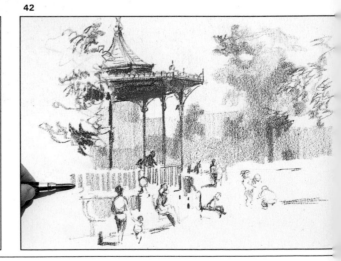

42

Fig. 41. Ballestar has drawn a framework of dark lines to define the bandstand. These lines, drawn black over black, have turned the bandstand into the central subject of the sketch.

Fig. 42. Within a sketch, every subject must become a pictorial motif, no matter how picturesque subjects may be individually. The consideration of a motif in terms of light and shade forces us to simplify the shapes of any single element, such as a fence or a human figure.

delineate the bandstand. At this stage of the sketch (see figure 39) these lines form a whole that is rich in tone.

The key to this sketch is the simplicity with which the different tonal areas are organized. Lines create the necessary tonal variation to differentiate distinct planes. The effect of the tonal variation is evident in figure 40. In this figure you can see how the black silhouette of the bandstand is separated from the lighter background.

The organization of this sketch emphasizes the sensation of depth through the use of light, medium, and dark tones. Ballestar has used the lightest and darkest tones in the foreground and has reserved the medium tone for the background. To direct our attention to the fence around the bandstand,

he has simplified the fence in the foreground (fig. 42), by reducing it to several short, broad, parallel strips.

By moving the bandstand, the central motif, to the left side of the composition, the artist has created a sense of asymmetry. He has counteracted this imbalance by darkening the upper-right area of the background. As you can see, in figure 43, he has left the human figures undefined; this helps to draw us, the observers, into the sketch, by suggesting space and directing our attention toward the background.

Fig. 43. The finished sketch is an excellent example of what can be achieved with a graphite pencil.

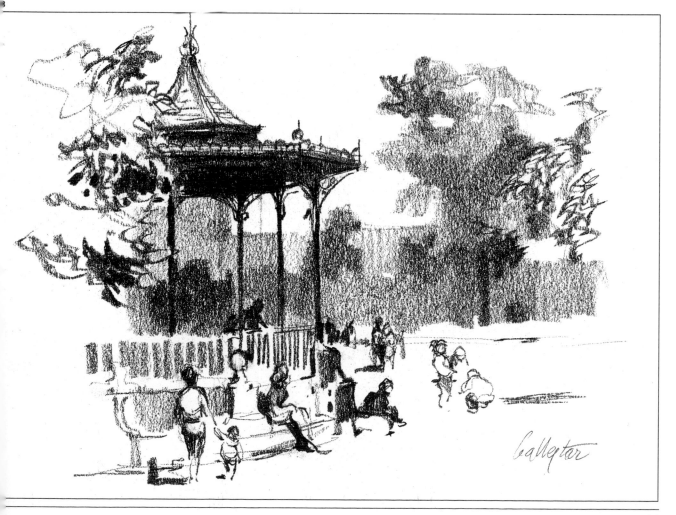

A gouache sketch

44

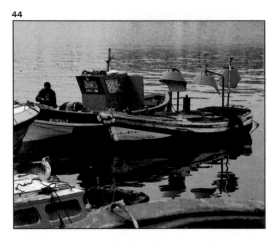

This group of fishing boats is the subject for Ballestar's next sketch. He decides to demonstrate a gouache technique, using watercolor paper mounted on a wooden board as his sketchpad. As you know, gouache is opaque watercolor. Just like transparent watercolor, gouache paints are diluted with water and applied with a brush.

Learning the technique of using gouache is an important step along the path that leads to watercolor painting. Gouache is of course an end in itself; it is especially useful for establishing lights and shadows, or tonal variation, within a work.

Before applying the gouache, Ballestar pencils the preliminary outline of the subject. He uses gentle strokes that barely touch the surface of the paper.

Ballestar starts painting the central fishing boat with a very dilute wash of sepia colored gouache. The first areas of color introduced into a sketch or watercolor are always the lightest. When using gouache, you must follow the basic rule of watercolor: work from light to dark adding stronger valves as you proceed.

As you can see, in figure 46, Ballestar uses contrasts to determine each value with respect to adjacent areas. Light areas appear even lighter when contrasted with adjacent darker tones.

45

46

47

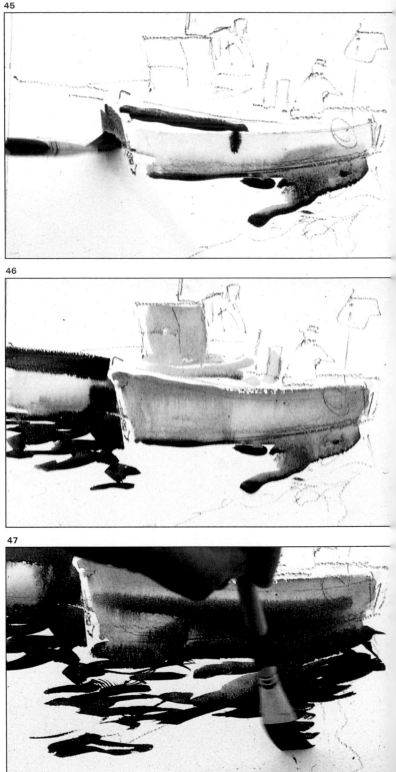

Now the artist emphasizes the shape of he boat with long, dark brushstrokes of olor, drawing the reflection of the boat on he water. Look at figure 47 and see the flat rush Ballestar has used to apply the strokes hat are the boat's reflection.

Now Ballestar chooses another brush, vith which he will draw the figures. He has

reserved several white areas to represent areas of light, and small patches cleverly combine the different tonal densities with these white areas. He continues to strengthen specific shadows to separate the boat from the surface of the water. Finally, with a very thin, diluted layer of gouache, he retouches the upper areas of the boats, and the gouache sketch is complete.

Fig. 50. The subject has been represented with areas of light and shadow; monochromatic values have been used exclusively.

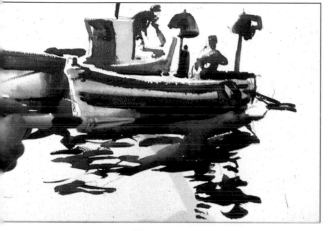

8

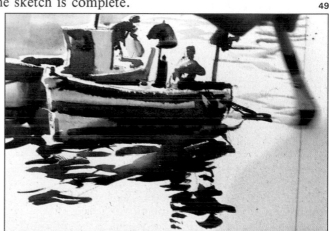

49

g. 44. The artist must ork quickly because ese boats will soon leave e docks.

gs. 45 and 46. Sketching ith gouache means orking from less to more ecause, as with water-olors, an artist cannot lay light color over a darker ne. It is also necessary to serve white areas when orking with gouache.

g. 47. Ballestar uses the of his flat brush to sug-st the movement of the rface of the water.

g. 48. At this point in the etch, Ballestar demon-rates how it is possible to ry a tone by modifying ly the adjacent tones. A lor will appear darker xt to a lighter color lue; this is simultaneous ntrast.

g. 49. When sketching, s important to keep the bject in mind, but the olution of the work ould always be the mary concern.

50

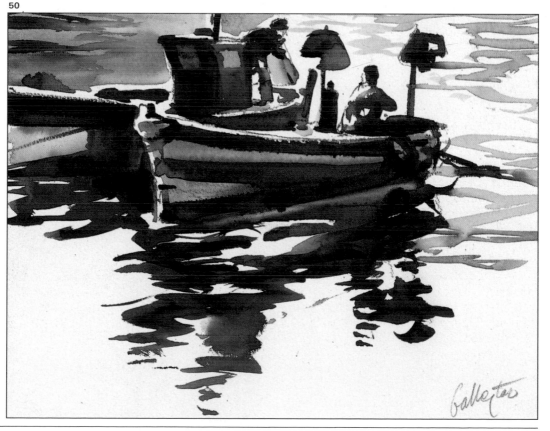

Sketching figures in pastel

51

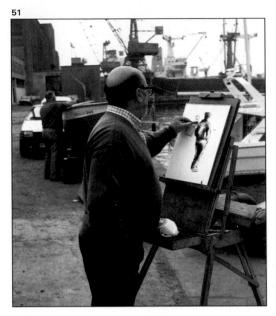

52

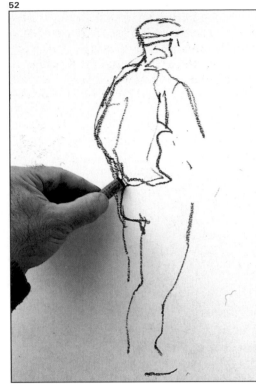

Fig. 51. Ballestar has foun[d] a new subject to sketch o[n] the dock. The model ha[s] not noticed the artist's a[t]tention and maintains [a] natural pose.

Fig. 52. These simple line[s] form the initial outline o[f] the model. Despite its ea[r]ly stage, the sketch alread[y] possesses character.

Fig. 53. When working [in] pastel artists often wo[rk] with their fingers, becaus[e] the perspiration and greas[e] from the fingertips help [to] bind and set the pastels[.]

In search of the subject for his next sketch, Ballestar carefully observes the port. He considers several possibilities, including the dock, some other boats, and figures. He uses his hands to frame the potential subjects. Finally he chose his subject, and we watch him set up his drawing pad on the easel. He picks up a black pastel and begins to draw a man working next to a boat.

Before starting work, the artist has familiarized himself with the man's overall posture. Now he starts to draw spontaneously to build up the outline of the figure. Ballestar is defining the man's posture, catching him with his back turned, slightly stooped. He establishes simple, but highly expressive gray areas; he obtains this effect, which can be seen in figure 53, by stumping the pastel with his finger.

54

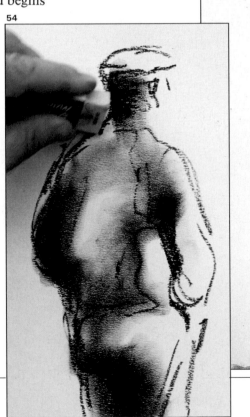

53

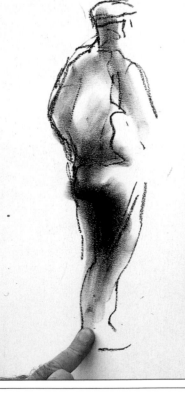

Fig. 54. Pastels, unlike other pencils made with oils, varnishes, or essences, can be erased with an eraser. This distinction makes up for the instability and fragility of the medium.

Now that Ballestar has added arms, and stumped some even darker areas, the figure is finally situated. He then uses an eraser to clean up the area around his figure that was stained by the pastel stumping. To spice up the sketch, the artist adds another figure. Ballestar simply captures a new pose of the original model. The drawing is enriched by the inclusion of a more distant plane. Ballestar reduces the size of this new figure, renders the lines and stumped stains more gently; this contributes to the sensation of depth (fig. 56). Ballestar completes the sketch by linking the two planes with a boat. Light, gray stumping on the boat helps unify the composition.

Fig. 55. Pastels are considered the most malleable medium, and one that offers the purest, richest colors.

Fig. 56. In this figure we observe the same technique demonstrated in earlier stages of the sketch. Spontaneous lines outline areas of gray and white, and in turn, these areas define light and shadow.

Fig. 57. This pastel sketch is the result of combining two separate poses of a model within one sketch. This sketch is the drawing equivalent of a photograph.

57

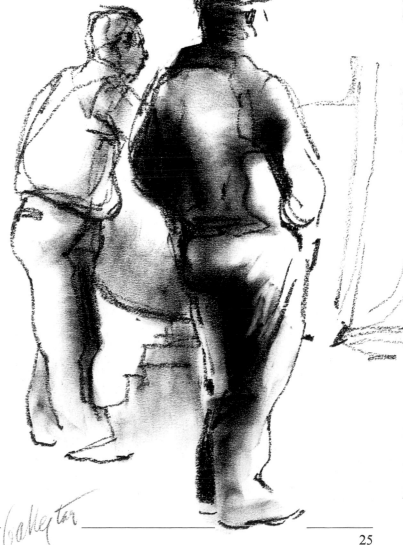

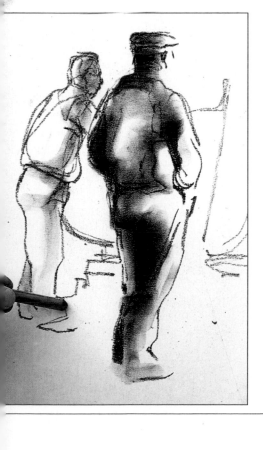

Sketching with color

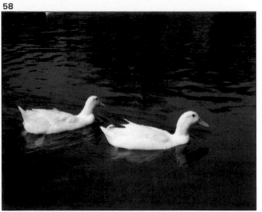

58

Ballestar leads us to another corner of the park. Here we find a new motif, a pond, a place the artist visits often. Ducks (see figure 58) are the subject for his next sketch.

After quickly sketching one of the ducks on watercolor paper, Ballestar takes up his paints and applies initial strokes of blue. This first application of color will define the character of the finished sketch and therefore "must be done well," says Ballestar.

He continues to paint, adding pure green and blue values. He uses these colors to surround the outline of the duck, and to estab-

Fig. 58. This charmi[ng] couple is the last mo[tif] Ballestar will sketo[h.] Watercolor is an excelle[nt] choice to complete t[he] task of capturing the flui[di]ty and movement of t[he] water.

Fig. 59. Remember th[at] the ultimate goal of wat[er]color painting is to captu[re] a refreshing interpretati[on] of the subject.

Fig. 60. Here Ballestar uses a technique similar to gouache. The artist lets the colors make their own impressions, while he skillfully reserves the necessary white spaces.

Figs. 61 and 62. He uses his smallest brushes for this sketch so that he can paint with precise strokes. This palette contains the colors he usually uses.

59

60

61

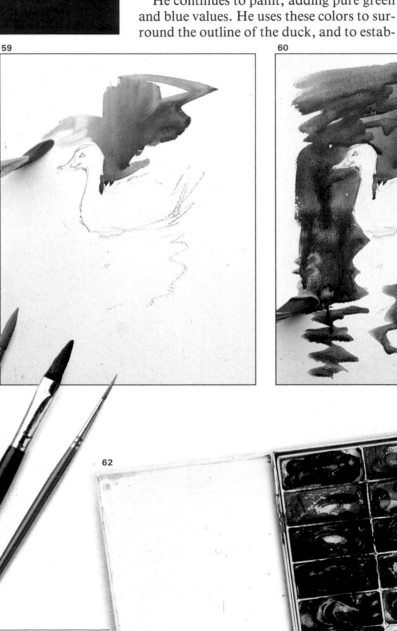

62

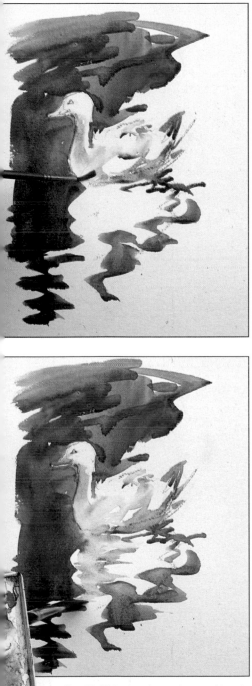

lish the duck's reflection in the water. Notice the calculated reservation of white space.

Ballestar paints the duck with several strokes of grayish, warm, broken color. He lets white breathe through (see fig. 63) and this produces certain areas of light.

To complete this sketch, the artist highlights such areas as the beak with a few strokes of intense color and then adds a yellowish hue to the reflection of the duck in the water (fig. 64). He completes this sketch by suggesting the duck's wake with a very fine greenish line.

Fig. 63. Ballestar works with both precision and ease, because of his experience and skill. He is able to overcome the rigidness that may result when an artist has to render excessive details.

Fig. 64. Ballestar sketches in the reflection of the duck on the water. The sketch is almost complete.

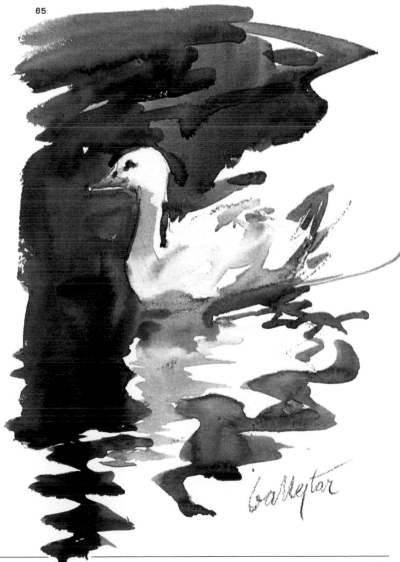

65

Fig. 65. This sketch may be considered a finished work. Ballestar was able to combine color harmony and skillful brushwork to get an impressive result. Because of the movement of the animals, he has had to work almost entirely from memory. Since animals tend to ignore our wishes to remain still, artists must be able to quickly capture their movements.

Ramon Noè, the art of drawing

66

67

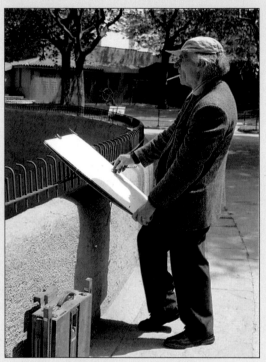

Fig. 66. Ramon Noè draws at the zoo, resting his folder on the fence in front of him. Noè's face expresses intense concentration on his subject.

We have invited Ramon Noè, a magnificent draftsman and painter, to contribute his work to this book; he is going to sketch some animals at the zoo. The painter adores using animals as subjects, ''... for the simple reason,'' explains Noè, ''that animals don't care if they are being painted. They don't pose and they don't turn away—they behave naturally.''

Noè was born in Barcelona in 1923, and studied drawing, painting, engraving, and ceramics at several schools throughout Spain. Later he taught drawing classes at the prestigious Massana School in Barcelona. He retired after more than thirty years of teaching and now continues to paint professionally.

The artist often took his students to the zoo, and on these visits he taught them to appreciate and master the art of drawing. He believes teaching is a matter of setting guidelines and instilling strong work ethics in his students to foster qualities of respect, curiosity, and perseverance.

Noè's animal drawings are all interesting, whether due to the shapes expressed or the techniques used. Look at the drawings on the next few pages. They seem so simple, yet the artist's understanding of the characteristic anatomical shape of each animal is apparent.

Noè also paints landscapes and portraits and experiments constantly with new techniques. Once he feels he has mastered one method, he practices another until he feels he is proficient.

We are at the zoo on a splendid spring morning. Noè arrives carrying a cardboard folder, a portable easel, and a bag containing basic materials: pastel pencils (sanguine, gray, and bister), soft pastels, ink, and a reed. To sketch animals, an artist must be relatively quick, and materials like these make the job easier. The paper Noè uses, which he stores in the folder, is of various textures, colors, and sizes. The folder also serves as a support for those times when the artist sketches on paper without using an easel.

Fig. 67. Here are the materials Noè will use to draw the sketches on the following pages. Note the different markings and the range of thick and thin lines that can be obtained with them.

Noè's animal sketches

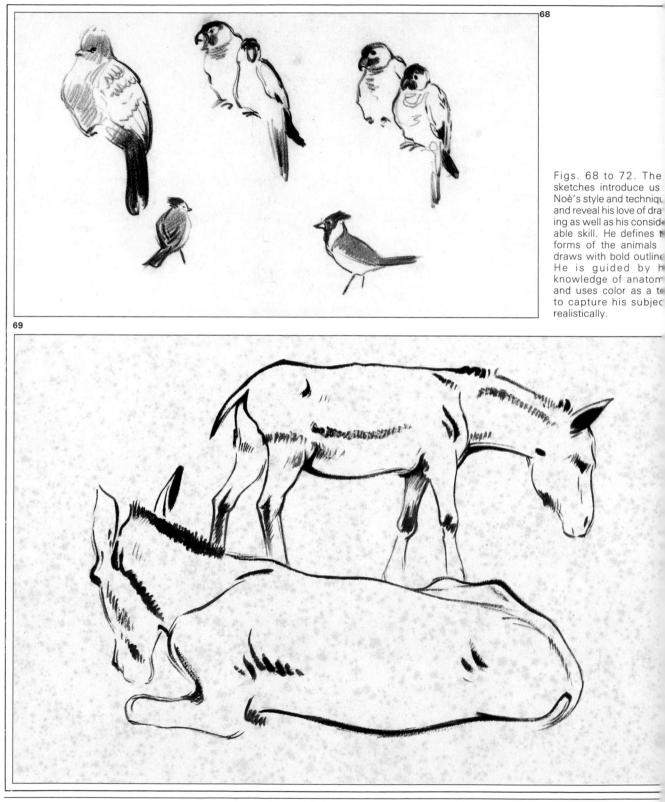

68

Figs. 68 to 72. The sketches introduce us Noè's style and techniqu and reveal his love of dra ing as well as his consid able skill. He defines t forms of the animals draws with bold outline He is guided by h knowledge of anatom and uses color as a t to capture his subjec realistically.

69

Ramon Noè has completed many pictures using various techniques. Here on these two pages are some works he has done in colored pencil and chalk (fig. 68), sepia ink (fig. 69), gouache (fig. 70), ballpoint pen (fig. 71), and crayon (fig. 72). Quite often, Noè paints on any piece of paper or cardboard within arm's reach, and he takes advantage of all potential subjects. Although he doesn't paint animals exclusively, these particular drawings are especially instructive. These are study sketches that enable artists to observe and capture their subjects in different positions and to focus on specific parts of the animals' bodies.

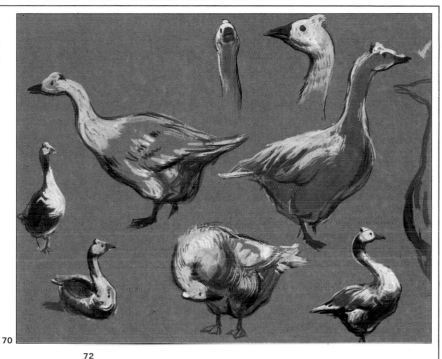

70

72

How Noè works

We are now going to study Ramon Noè's approach to his work. Look at the sketches and studies on these two pages. Four different animals are represented here: lions, cows, camels, and tigers. Noè has used a different technique to sketch each of these animals. If we study these pages, we can learn both how to draw animals and how to sketch.

"You must draw a lot of animals before you can draw them well," remarks Noè. How should an artist begin? Start by closely observing the shape of the animal—the overall outline and body structure. Noè refers to this process of observation and interpretation as "defining the framework" for the composition. Compare the shape of the tiger's head with the head of the lion. "The tiger's head is shaped like a circle, while the lion's head is shaped more like a rhombus," adds Noè. The artist begins by drawing simple lines (see figure 77) that build up the shape, and continues until the figure resembles the tiger.

73

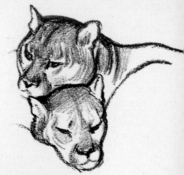

74

Figs. 73 and 74. These lions snuggle up to one another, stroke each other, and cuddle. Noè has sketched the shape of the two forms as one shape, carefully indicating how the bodies entwine. Notice the simplicity of the shape, which results in a sensitive drawing. You can also see how a heavy outline adds to the impact of the single form.

75

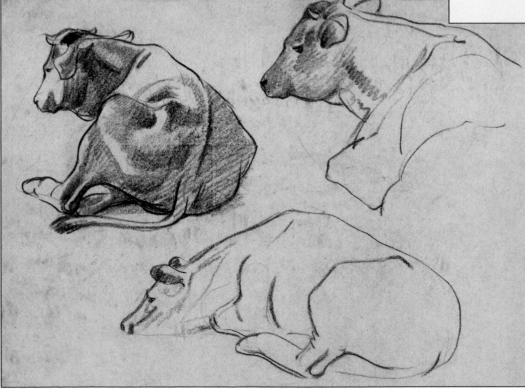

Fig. 75. On a single sh⁅ of paper, Noè has sket⁅ ed a resting cow in th⁅ positions. The artist use⁅ sepia pencil to mak⁅ quick, shaded study of ⁅ cow's head. The cow st⁅ ed in this position for ⁅ extended time, so N⁅ sketched her once aga⁅ this time with her head ⁅ the ground. Sepia is a v⁅ satile material to w⁅ with; you can draw ⁅ lines, or shaded area⁅ with the help of a fing⁅

Now look at the camels (fig. 76). Here you can see some faint lines, which are the first ones Noè has drawn. The artist concentrates on the proportions of the subject, first by defining small shapes that make up the whole, and then by joining these shapes together to build up the figure. He darkens shadows and strengthens the lines to determine the outline. These lines are precise strokes that become stronger and thicker as Noè decides how he wants the animal on the paper to appear. He takes a fresh piece of paper to capture the animal in another position and to study the facial features in detail.

Fig. 76. Here Noè used a lead pencil, a medium that results in both crisp and soft lines and allows for other effects when stumped and smudged with an eraser. Noè observes and sketches the camel by drawing the changes in the animal's position, constantly measuring proportion from the animal's overall shape. The artist uses subtle, sensitive markings, lines that suggest rather than boldly state the subject.

Figs. 77 and 78. Here again are three images of a single figure. The first incomplete sketch reveals how Noè establishes space and volume with just a few lines. Below the faint line sketch is a perfect study of a tiger's head. In the sketch of the full animal's body, Noè has effectively captured the impression of light and shade, and the tiger's physical characteristics, particularly its ferocious expression.

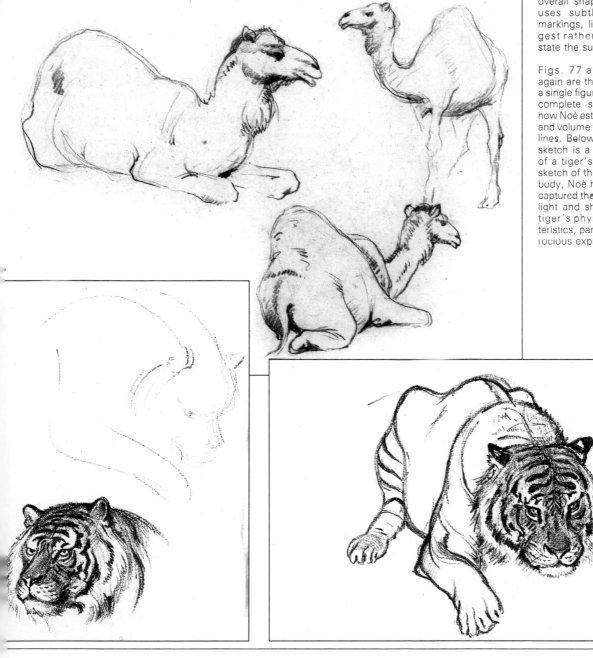

78

Bison: reed and ink

Fig. 79. Bison are beautiful, powerful animals. Noè will sketch one, using ink and a reed, while it is resting. He notes that no matter what position the animal is in—facing the viewer or back turned—the body is essentially a geometrical shape. This shape is the first thing an artist must be able to visualize before beginning to work.

Fig. 80. Using reed and ink, Noè draws two curved lines that form a half moon to represent the bison's horn.

Figs. 81 and 82. The remaining shape of the bison is drawn in with soft, flowing lines. Ramon Noè sketches with precision, adding small vertical marks to the shaded areas to create a sense of volume.

79

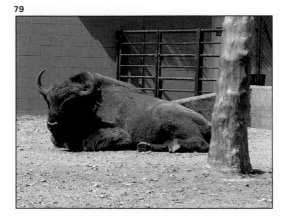

Now that we have seen Noè's animal sketches, let's look at a step-by-step demonstration by the artist. Noè has decided to sketch a bison, an animal that usually keeps relatively still.

Noè sets up his easel and prepares some $14 \times 18''$ (30×45 cm) white sheets of paper.

He makes a preliminary sketch with a sanguine pencil. (That sketch is not pictured here.) He then opens a bottle of ink and prepares a reed, one that he himself cut to suitable size. He explains that reeds improve with use. He looks at his subject; the bison is in a resting position, reclining with its back facing the public.

Noè dips the reed into the ink and rehearses the movement of his hand and arm before touching the reed to paper. He forms a triangle in the air with an arm motion to capture the shape of the reclining bison. Noè reminds us that the first and most important step an artist must take before beginning to sketch is to determine the shape, the structural outline of the subject.

In the midst of one of Noe's arm motions the artist finally places the reed onto the paper and makes his first marks. These lines are fine, wavy, and segmented. Noè then draws some fine-hatched lines, which indicate a shadow near the bison's ear. To draw the horn, the artist dips the reed into the ink once again and draws two curved lines thicker and stronger than the first wavy strokes. He draws in the rest of the animal with gentle, wavy lines.

80

81

82

s. 83 and 84. Noè has
rted a sketch of the
ad of a bison. The artist
ntinues with the same
hnique he used before,
ving the reed gently but
idly over the paper to
ke short strokes of vary-
thicknesses and direc-
n. To complete the
tch, he suggests hair
d ''beard'' with short
tical lines.

85. Here is a page of
è's completed India ink
tches.

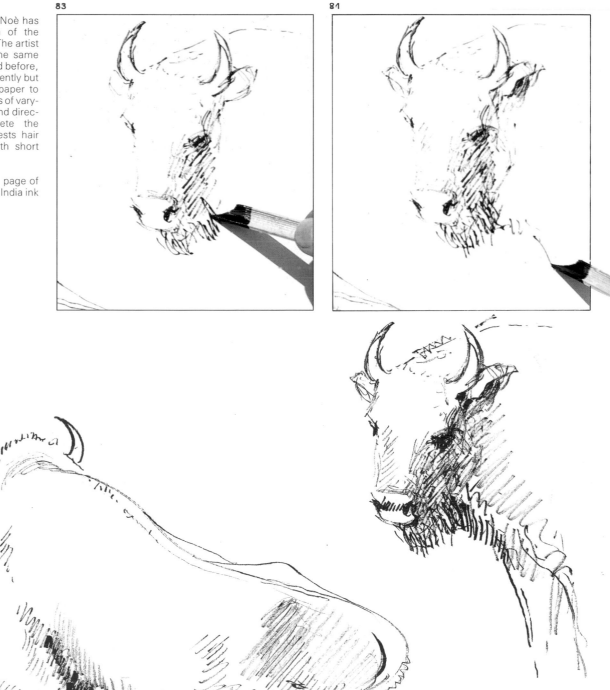

Ostriches: sanguine

We are watching three strutting ostriches. Unlike bison, these animals are constantly in motion, and will be more challenging subjects. Noè explains two things: first, that artists must draw animals many times over in order to capture their essence; and second, that artists must continuously look at their subjects as they sketch. Noè looks at one ostrich and indicates its outline with a number of graceful lines. He then refers back to his subject, or any one of the ostriches, for the information he needs to capture and accentuate the characteristics and details of the animal.

Noè picks up a sheet of paper and a sanguine pencil. He draws an oval and two long lines that become the bird's neck; he is sketching the ostrich in profile. He remarks that an ostrich's neck always reminds him of a snake. He draws faint lines very close together, almost one on top of the next. Both the general shape of the body and the neck, as well as the feathers that characterize this large bird, are formed by these overlapping lines.

Remember that an ostrich is a very large bird with two enormous and powerful feet—an ostrich can actually be ridden like a horse. Noè has sketched what appear to

86

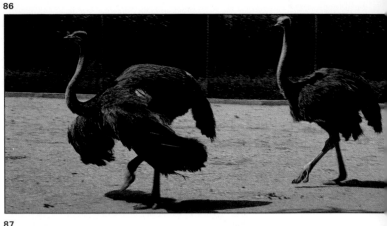

87

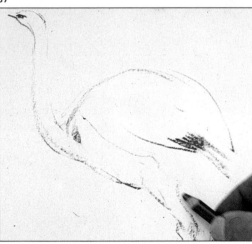

Fig. 86. These ostrich strut about constant their heads held high. Th appear strong and comi at the same time. sketch moving anim successfully, you must ways determine their g metrical forms and prop tions before beginning work.

Figs. 87 to 89. Noè dra with great precision a care; it seems as if the li spring from the per without any effort on part of the artist. It is a the pencil moves in the in search of the right li approaches the paper, a draws independently. know, however, that N is responsible. He rend the oval shape of the trich's body, and then neck and the head. Th rubbing his sanguine p cil on the paper, he s gests the overlapp feathers of the bir wings.

Figs. 90 and 91. If the trich is seen from a fr view, the shape of body is practically a cir Noè is now defining body and sketching in feathers. Next he will w on the feet, leaving the foot half-drawn to sugg movement.

88

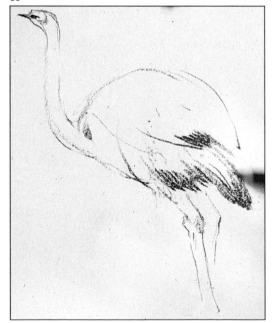

89

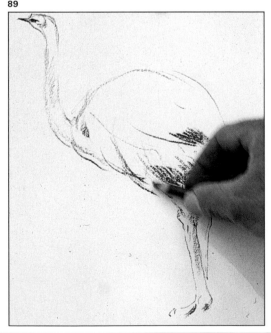

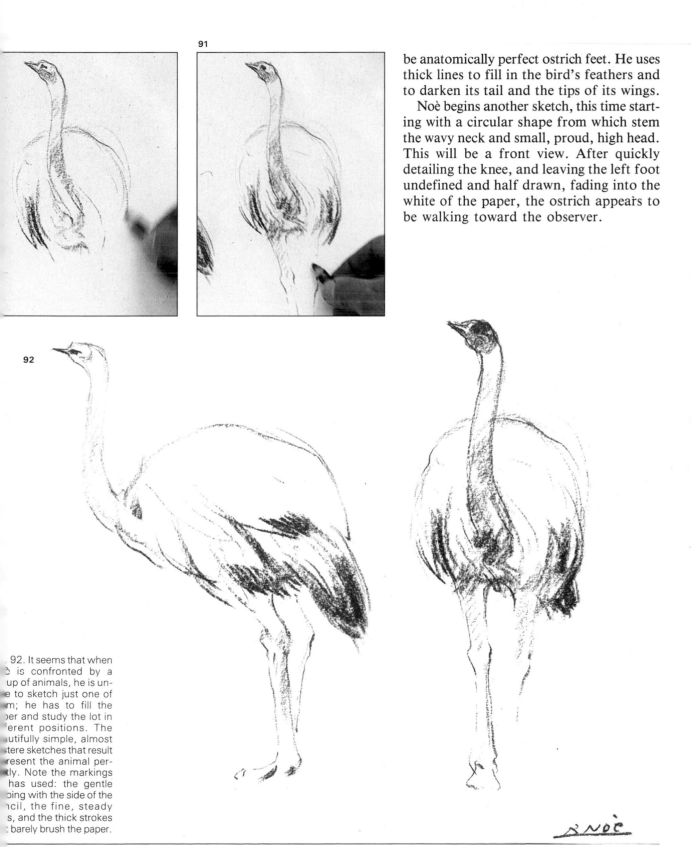

91

92

be anatomically perfect ostrich feet. He uses thick lines to fill in the bird's feathers and to darken its tail and the tips of its wings.

Noè begins another sketch, this time starting with a circular shape from which stem the wavy neck and small, proud, high head. This will be a front view. After quickly detailing the knee, and leaving the left foot undefined and half drawn, fading into the white of the paper, the ostrich appears to be walking toward the observer.

92. It seems that when ɔ is confronted by a up of animals, he is un- ɘ to sketch just one of m; he has to fill the ɔer and study the lot in ̄erent positions. The ̄utifully simple, almost ̄stere sketches that result ̄resent the animal per-̄tly. Note the markings ̄has used: the gentle ̄ɔing with the side of the ̄ncil, the fine, steady ̄s, and the thick strokes ̄ barely brush the paper.

ʁΝῸ

Pelicans: pencil and pastel

93

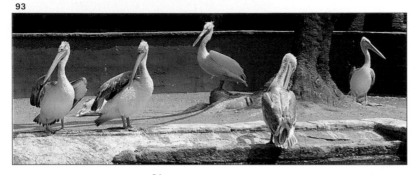

Fig. 93. The sight of this group of pelicans splashing in the water inspires Noè to start another sketch.

Figs. 94 to 97. Noè uses a gray pencil to fill in the shaded areas on the animals' bodies, stumping the lines he makes with his finger. He then adds white pastel to define the light areas and stumps with his finger once again to reinforce a gray line. The artist follows this procedure to sketch each of the birds you see in figure 98 on the opposite page.

94

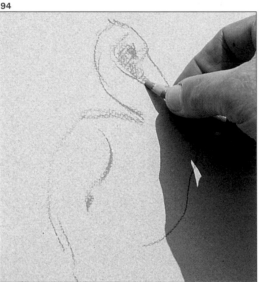

We were strolling around after a sho coffee break, when a group of pelica caught our attention. Noè is inspired by t characteristic elegance of these birds, wi their silver and white colors and their shap He immediately sets up his easel; he choos 20 × 24″ (50 × 65 cm) gray-colored Cans paper, and he selects a dark gray pencil a a white pastel from his bag.

The artist pencils in a few gray lines define the curve of the neck, the head, a the straight beak. He continues drawi with the pencil, drawing the outline of t body and the first lines to define the win Noè stumps these lines with a finger, to su gest the round form of the bird's body

Next, he picks up the white pastel a highlights areas on the head, the neck, a the body, all the while keeping the gr shadowed areas untouched. Noè has cre ed the illusion of volume with white pas contrasted with gray paper, with the effe of stumped gray pencil, and with da heavy gray lines.

95

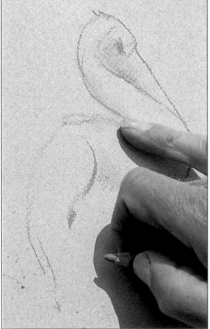

96

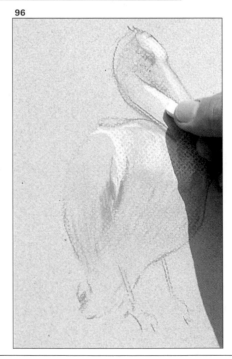

97

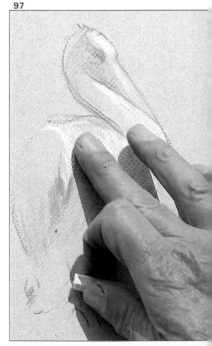

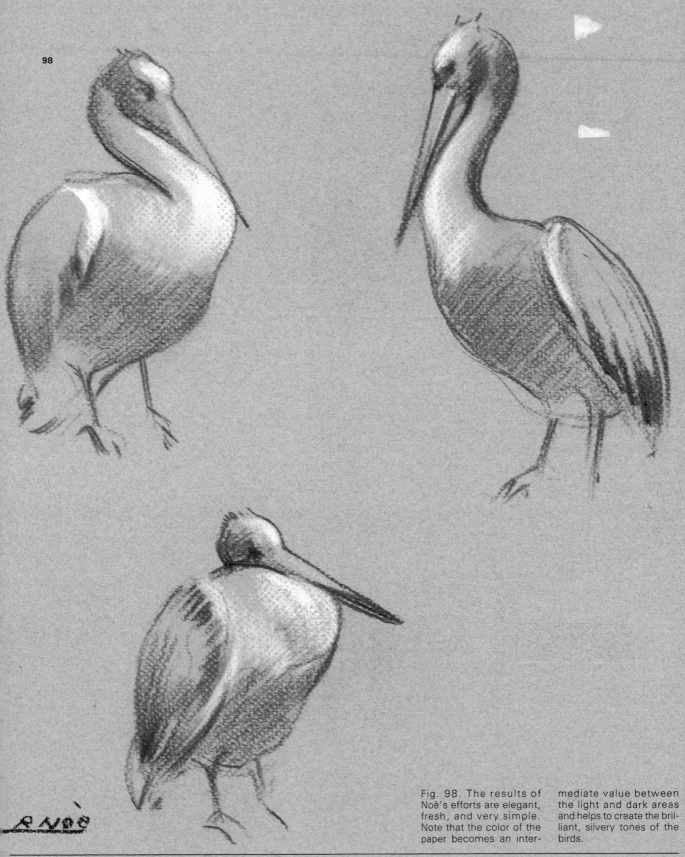

Fig. 98. The results of Noè's efforts are elegant, fresh, and very simple. Note that the color of the paper becomes an intermediate value between the light and dark areas and helps to create the brilliant, silvery tones of the birds.

Miquel Ferrón: artist and teacher

99

Teaching people how to paint and how to perform any creative task is a challenging proposition. Miquel Ferrón seems to have found an answer to this dilemma, by combining his job as a drawing teacher at a well-known art school in Spain, with his career as an artist, professional designer, and illustrator. So we were not surprised by his willingness to contribute to this book, or by his desire to make this session truly useful. His professional skills and talent guarantee that he is an ideal person to demonstrate sketching techniques.

In his study Ferrón has set up a simple table, made with a wooden board and two easels. On this table he sets down several wide, bevel-cut, felt-tipped markers or pens alongside a palette box of gouache. He adds a sheet of Scholler paper, which he attaches to the board; this paper, similar to cardboard, has a matte surface. "I use it," says Ferrón, "to avoid the finished work looking like a watercolor painting."

Combining techniques

Ferron will use a combination of techniques to sketch, as you may have guessed from the materials shown on the previous page. Felt-tipped pens and gouache are materials artists must use with a clear, definite objective, because there is less adaptability when working with these materials than with, for example, charcoal. Lines drawn with charcoal may be thick or thin, depending on the amount of pressure the artist exerts while holding the pencil. Charcoal lines can be smudged with a finger, stumped, and even erased. Felt-tipped pen marks cannot be altered easily. Artists must consider the mediums they are working with when planning a composition.

Ferrón, as a professional artist, is very familiar with the technical possibilities of felt-tipped pens. He cautions us with an important message: He will demonstrate traditional methods of working with these pens on the next few pages. Ferrón has developed his own style for working with this medium, adapting these pens to more artistic uses, as we will also see later.

Combining colors

When you wish to combine hues in the same color family—for instance, a light green and a dark green—you must do this quickly; apply the darker color on top of the lighter color, before the lighter color evaporates.

Parallel lines and superimposing

The most common technique for covering large areas with a continuous color is to apply the felt-tipped pen in broad, parallel, even strips. You can distinguish planes by changing the direction of the strokes. Superimposing color—drawing a color over itself again and again itself—produces changes in value, making the color deeper and richer. If you draw two transparent colors adjacent to one another, a chromatic change will result.

Fig. 99. Miquel Ferrón is professional painter an draftsman who combine these specialties with profession as an art scho instructor. This combina tion of experience and ta ent make him the idea person to explain his tech nique concisely and clea ly as he demonstrates h skill.

ombing and sweeping

A surface is combed or swept when the rokes of the felt-tipped pen follow the hape or rhythm that the surface suggests. rtists must constantly adapt their work to he demands of perspective.

There are many marker techniques you an utilize to express aesthetic emotions. on't hesitate to try new methods, and do ot conform to using traditional methods xclusively. Satisfy your curiosity; experi- ent and explore to discover new and un- pected ways to use felt-tipped markers.

Fig. 100. Here are the materials, felt-tipped mark- ers, paintbrushes, and gouache, with which Fer- rón will sketch the subjects on the next few pages. The strokes of the felt-tipped marker (1) structure the framework of the sketch, and provide the basis for color, while the gouache (2) is used to stump and soften the effect of these markers. The brushes (3) Ferrón paints with are made with Japanese ny- lon, instead of sable hair, and enable him to draw the brush over the paper more easily.

Miquel Ferrón's work

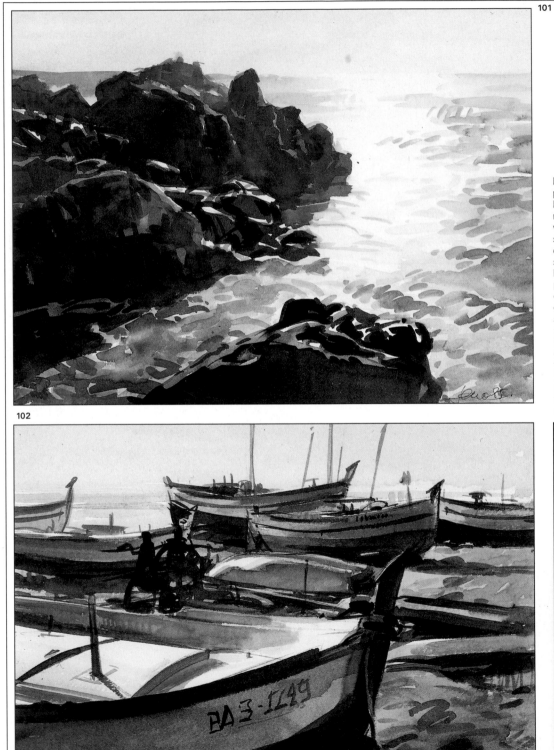

101

102

103

Figs. 101 to 105. The
paintings introduce us
Ferrón's style and tec
nique. Ferrón has us
watercolor, oil, chalk, a
sanguine to obtain varic
effects. Lively, flowi
seascapes are group
here with other wor
painted in a more relaxe
contained style. Inter
gardens are shaped de
sively. The subjects of
portraits and nudes ha
intense features and w
defined profiles on wh
the artist has left his ma
Ferrón's work is charac
ized by his versatility
technique and expressi

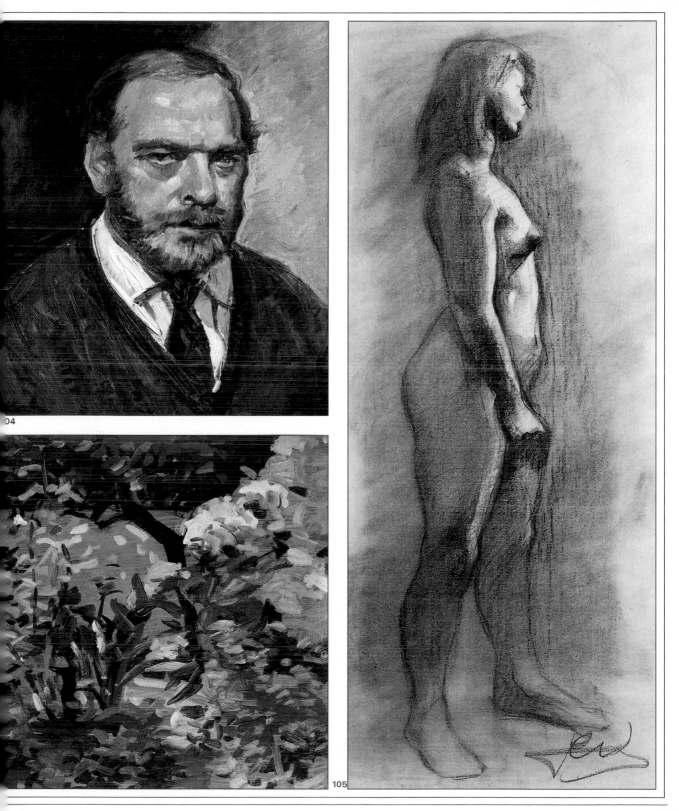

04

105

First sketch: drawing and painting to make a sketch

106

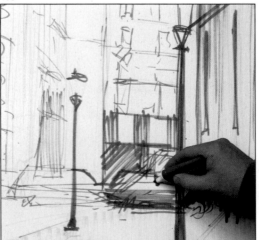

Ferrón has brought with him a series o
photographs that will serve as possible sub
jects for this sketch. Figure 106 is th
photograph of the motif the artist has chos
en to sketch. The small city square is fille
with attractive sunlight and atmosphere.

We are ready to begin. Ferrón establish
es the first structural lines to compose th
motif; he uses broad, bold lines to represen
the lamplights and the prominent buildin
on the right. Fainter lines are used to estab
lish planes and create perspective and a fee
ing of distance. These lines have receive

107

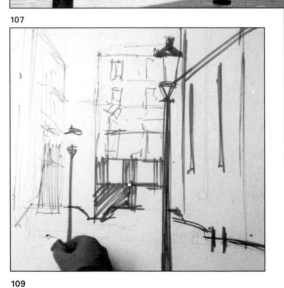

108

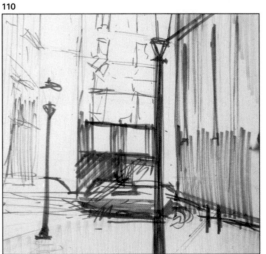

109

110

Fig. 106. Miquel Ferr
often roams the streets
the city with his camer
Later in his studio,
renders the subjects of
photographs in watercol
oil, chalk, pencil, felt-tip
ed marker, and so on. Th
photograph will be the su
ject of Ferrón's first sketc

Fig. 107. The artist fi
pencils in an almost imp
ceptible outline of the su
ject. Next he lays down
definitive framework of
structures with a gray fe
tipped marker. -

111

112

113

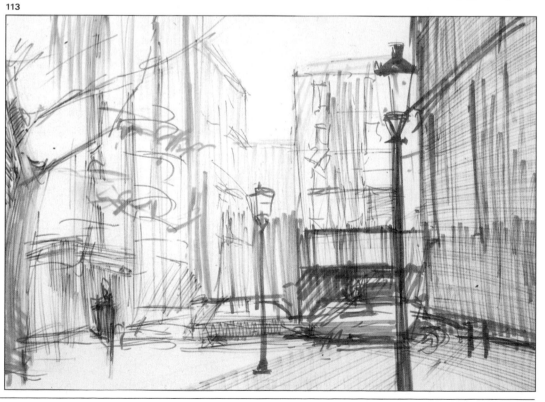

g. 108. This set of lines
presents the structure of
e motif in the photo-
aph. Started from the
ilding in the right fore-
ound and leading to
ose facing us in the back-
ound, tho vanishing lino
perspective and the
ferent planes have been
tablished. The artist has
adually added other
apes, including the
eetlamps, the tree in the
eground, and the cars in
e distance; this figure is
e complete initial frame-
ork of the motif.

. 109. Ferrón works
nfidently with the felt-
ped pen, correcting and
odifying as he prog-
sses.

. 110. He adds patches
vertical, horizontal, and
gonal lines of blue and
k gray, to indicate the
adows cast by the build-
on the left.

. 111. The upper left
adrant of the photo-
ph shows plenty of sun-
t in the scene. The art-
sketches long, parallel
es with the ochre-yellow
rker to recreate these
lit areas.

. 112. Ferrón doesn't
to use green or black
shadows. He prefers to
resent shadows with
er dark colors; in this
e he is using violet.

. 113. Ferrón has used
felt-tipped markers to
ablish the shadowy
as, strenghtening cer-
lines and colors, and
ting at the first sensa-
s of volume and depth.

different treatments to structure the motif.
In Ferrón's opinion, the freshness and loose-
ness of a sketch depends on something un-
controllable.

In harmony with the color tendency of the
subject, the artist chooses six new felt-tipped
pens—three from the blue-gray range, two
ochre-yellow, and the last a dark violet. He
begins with the sky-blue marker and covers
the wall of the building on the right with a
set of uniform vertical lines.

Felt-tipped pens, like colored pencils, al-
low you to draw and color simultaneously.
They are well-suited to the task of synthesiz-
ing a composition, which is fundamental to
sketching.

Ferrón uses the ochre marker to empha-
size the illuminated buildings on the left side
of the square (fig. 111). He uses broken, ir-
regular, parallel lines to suggest height and
volume, taking advantage of the possibili-
ties provided by a wide, bevel-cut marker.

Before completing this stage, Ferrón cre-
ates shadows in different parts of the work
with the dark violet marker (fig. 112).

Adding watercolors

Ferrón is ready to add water and pigment to the sketch. He fills a jar with water and selects a flat, plastic-handled brush. The artist paints with a broken, bluish color that blends with the blue tone of the felt-tipped, base color. To get fresh colors, Ferrón adds water to the pigment in his palette box.

His efforts produce an extensive variety of broken or dirty tones, varying according to the color of the area he paints over. You can see how the watercolors affect the tones of the original marker strokes, resulting in

values of gray, blue, yellow, and crimson (figures 114 and 115). Ferrón paints with wide brushstrokes and quite a lot of water to dilute the felt-tipped base colors.

In this first sketch, Ferrón produces a set of abstract lines and stains, which our eyes reconstruct as defined sensations of volume and color. The purple and Prussian blue lines are fairly intense values in comparison with the overall tone and intensity that Ferrón has developed in the center of the sketch (fig. 116).

The sketch takes shape through the use of a range of cooler tones in the foreground that form the shadows cast by the building on the right. The artist uses warmer colors in the distant areas to capture the daylight that highlights the city street. Ferrón pauses for a moment . . . the sketch still needs work to be complete. He adds some gentle touches of black on the streetlamp to intensify the contrast in the foreground. This step highlights the sensation of depth and distance in relation to the background. Ferrón has decided to take advantage of the color of the paper, and leave the sky unpainted. He reserves the sky to achieve neutral contrast between light and shadow (fig. 117).

114

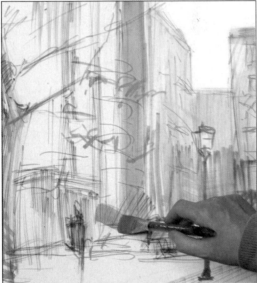

115

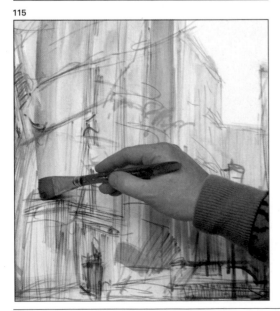

116

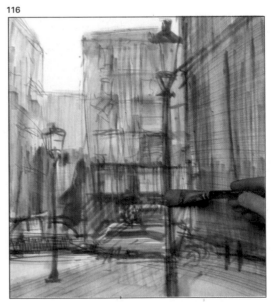

117

Fig. 114. The artist is p⊣ pared to add color to ⊦ sketch. He begins to p⌐ with the watercolor g⊢ ache and a flat brush. ⊦ the moment, he stains ⊦ entire surface with verti⌐ lines of color in a contir⌐ ous movement.

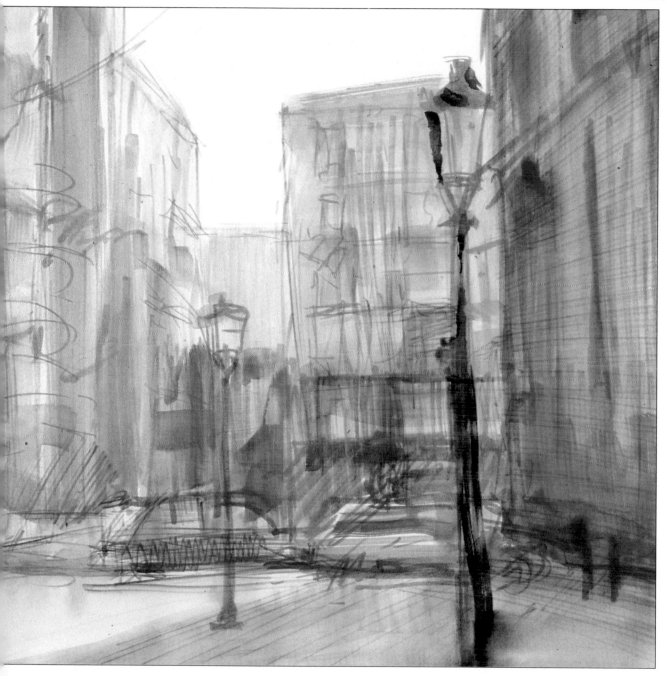

115. The brush is quite urated with water and ache paint, making it y for the artist to stump felt-tipped base color.

Fig. 116. In barely an instant, these brushstrokes have transformed the hard, defined framework and tones of the markers into a gentler, more suggestive whole, with more ''atmosphere.''

Fig. 117. The first sketch is finished. Ferrón has decided to leave the area of the sky white, making use of the color of the paper. Reserving the sky in this way creates a contrast between the light areas and the shadows. Contrary to custom, the foreground has been created with cool tones, producing soft backlighting.

Second sketch: composition

118

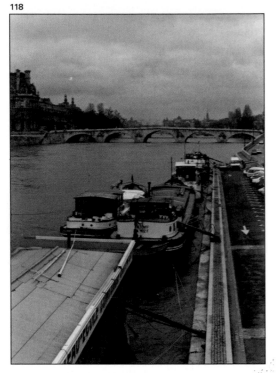

As we discussed previously, painters must warm up, immerse themselves in the subject, and develop a rhythm before beginning to paint. In Ferrón's case, the sketch he has just completed seems to have been enough to warm him up. He takes a moment to set up a new sheet of paper, this time vertically to adapt to the format of his next subject.

The new motif is another city view. Ferrón will now sketch a beautiful motif, a scenic view of the Seine in Paris, of the typical packet boats moored to the docks, including the majestic bridge in the background. This motif has been studied innumerable times throughout the history of painting, most often by impressionist painters.

After studying the photograph (figure 118), Ferrón establishes the line of the bridge; he defines the bridge as a horizontal axis located above the center of the paper. Then he creates the powerful diagonal line formed by the group of boats and the dock on the right. The artist has centered the vanishing point of this line by shifting the position of the line slightly to the left. He represents the group of houses and trees

in the background with zigzagging vertical lines. These lines vanish toward the center of the horizon line, to a point also located on the bridge (fig. 119). Ferrón begins to paint with a gray felt-tipped pen, and covers the entire right plane with zigzag lines. He uses a yellow marker to sketch in the pier with long, vertical strokes.

The artist exchanges the yellow marker for a red one, with which he fills in the shadowed side of the building that can be seen in the foreground (fig. 121). He moves to the background where, with ochre-

119

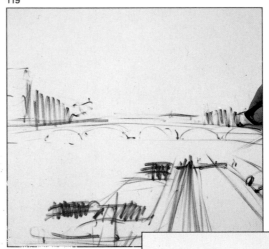

Fig. 118. The camera, a constant companion on Ferrón's trips, has supplied him with another subject to paint. Like the previous subject, this view of the Seine has a soft, even light, although the color of the scene is predominantly gray because of the overcast sky.

Fig. 119. Ferrón schematically delineates the lines of the composition with the gray, felt-tipped marker. Several groups of vertical zigzag lines are added in the background to represent all distant details of the motif.

Fig. 120. The framing and the high viewpoint created by the artist give the sketch a very high horizon line.

Fig. 121. These horizon and vertical lines of gray, yellow, and red are the framework for the criss cross pattern appearing throughout the sketch. Ferrón sketches these cross hatched areas decisively and with precision.

Figs. 122 and 123. By superimposing these lines and carefully regulating the density of the color strokes in the area, the artist can specify and control the value and intensity of each light and dark tone.

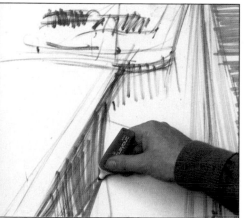

colored, broken lines, he continues to delineate the profile of the bridge. Ferrón uses purple, and then a dark, bluish-gray to suggest the presence and shape of the boats docked at the pier, and he then paints the surface of the water with the same bluish-gray value (figs. 122 and 123). The final figure on this page is the bare structure of the work before the artist adds watercolor to the stark marker strokes.

Fig. 124. Ferrón's desire to omit all irrelevant detail has led him to reduce his interpretation of the motif to a set of lines. When you observe the sketch from a distance, it appears to be composed of compact patches that effectively imply the vagueness of the background, especially if you focus on the horizon.

124

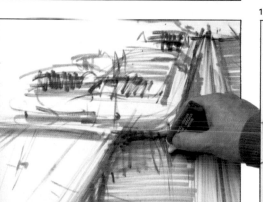

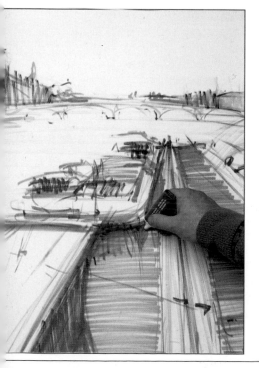

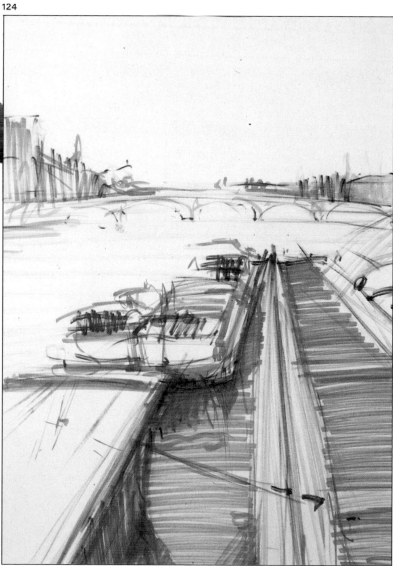

A framework of color

125

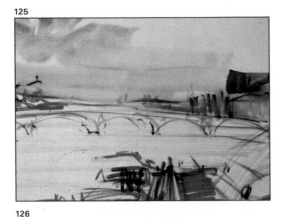

126

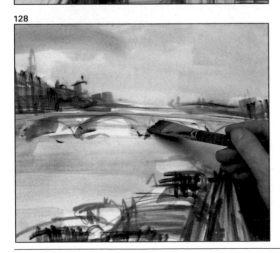

127

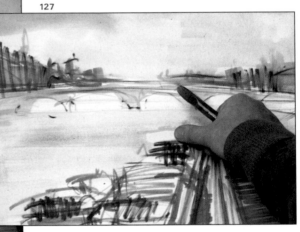

128

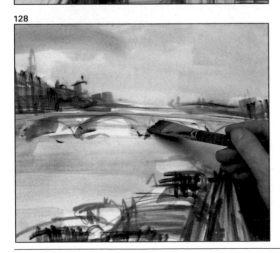

Ferrón explains how he will continue to work. "Once the color of the atmosphere has been achieved," he says, "I will add a few dark touches to define the sketch and then it will be finished."

He starts by freely spreading loose patches of light gray tones over the paper to paint the sky. A little blue and yellow are added to this soft wash as he approaches the horizon line (fig. 125).

The felt-tipped marker outlines fade and become hazy as the paper becomes saturated with the watercolor wash. A mood is suggested by the cloudy, overcast sky; the artist intentionally created this atmosphere to obscure and soften the stark marker strokes. This sensation is reinforced by the gentle wash that he spreads over the paper under the bridge, alongside the river.

Ferrón has perfect control over the spread of this wash. If necessary, he will lighten its effect and rub away the color with his finger (fig. 127). Another way the artist can control the wash is to repeatedly check and test the amount of water in the brush. You can see Ferrón regulating the amount of moisture the brush holds (fig. 129).

The range of gray values that Ferrón initially decided to work with has set the tone for the entire sketch. The final composition in figure 130 shows a muted sketch, with cool color values. The few bright tones of ochre and red are not enough to detract from the artist's emphasis of shadow on the overcast scene.

Fig. 125. Ferrón is rea to color the sketch w gouache, using a wash stain the area above t horizon and the river alor side the dock. He colo the sky with a gent broken gray tone. By a ding a yellow tinge to t horizon, the artist lends t sketch the luminos characterizing the area th separates the sky and t earth.

Fig. 126. In harmony w the hue of the sky, Ferr applies another very ge tle wash over the riv With this technique, t artist lessens the stark fect of the felt-tipped ma ers, fading the lines, a making them seen ha and indistinct.

Fig. 127. Each brushstr of a wash must be c trolled by the artist. Fer often resorts to using fingers to establish limits of the wash in e area. He can lighten the fect of the wash and away color with his fing At the same time, he c ates a sensation of li over the general gray t of the sketch.

Fig. 128. A single, w placed brushstroke on paper can suggest, a the arches of the brid the sensation of volum

129

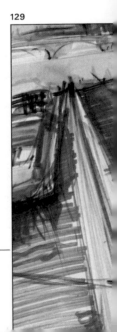

130

Fig. 129. Ferrón warns you to constantly regulate the amount of water you are working with. The easiest way to monitor the amount of moisture the brush holds is to test each brushstroke on a separate piece of paper before you add the wash to the sketch.

Fig. 130. This second and definitive sketch has taken shape through a range of broken colors tinged by the underlying felt-tipped pen. Miquel Ferrón's unique combination of felt tip markers and gouache has proven ideal for rendering a sketch in a short amount of time. Confirm this yourself by experimenting with this technique.

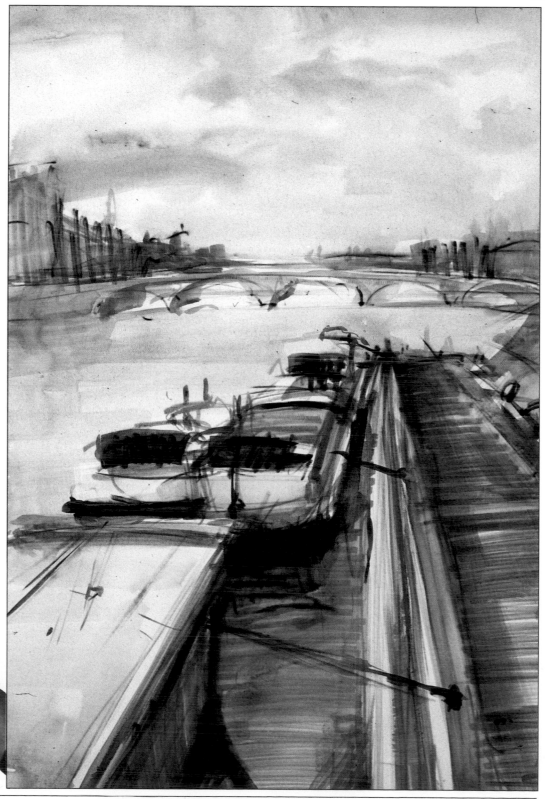

Monguillén: the desire to paint

131

Fig. 131. Luis Monguillén. We are going to observe this painter as he sketches subjects with diverse techniques. Monguillén loves to paint and has worked steadily since he made the decision to devote himself exclusively to painting, despite circumstances that made this decision difficult for him. Now as a painter who often has exhibitions, and who paints important mural works, he prefers to work on various subjects, especially landscapes and figures.

At a young age, Luis Monguillén decided to become a professional painter and devote himself entirely to painting. The decision to support himself solely by his work was not an easy one for the artist to make, and his first few months were challenging. Despite his difficult start, Monguillén today is an artist who has, among many other accomplishments, painted one of the largest murals in Europe, in the sports complex of a city in Spain.

Monguillén was born in the Andalusian region of southern Spain, and his painting career was launched in Paris. After five years he decided to settle in Barcelona, and that was more than twenty-five years ago. Monguillén wanted to explain a little of his background so that we can understand his artistic development and his interest in painting. He would like to stress that he never studied in an art school; he taught himself how to paint, and would discuss his work with his friends who were also painters. As we observe Monguillén at work we will discover other facets of his personality.

Fig. 132. These are th tools and materials Mo guillén will use to crea the art in this section. Loc at the enormous brush he uses to paint with w tercolors (1 and 4), th carved reed, an instrume essential to his techniqu (2), and the handle of brush that he carved hir self (3).

132

1 2 3 4 5

Monguillén's work

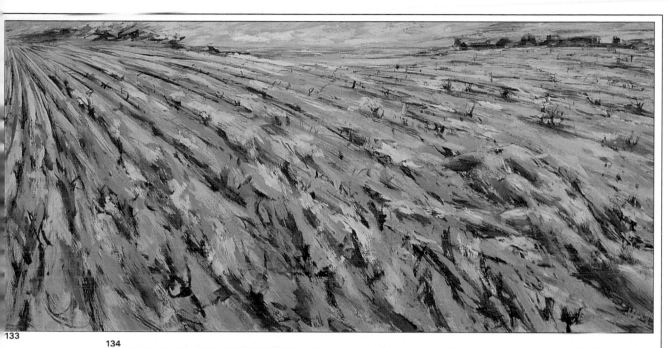

133

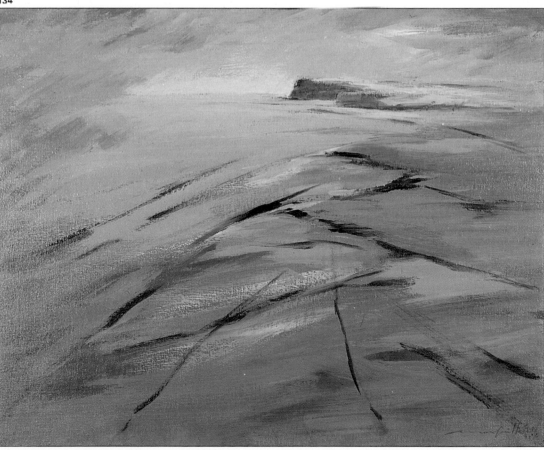

134

Figs. 133 and 134. Landscape oil paintings by Monguillén. The artist tends to introduce expression into the subject he is reflecting, turning the countryside pictured here into an emotionally rather than visually communicative subject. He captures a panoramic view of the scene with the placement of the horizontal plane high at top of the picture. The strong brushwork and color range contribute to his expressive interpretation of the subject.

First stage: sketching with patches of color

The first motif Monguillén will sketch is a port.

The artist explains that he wishes to differentiate himself in some way from other painters of seascapes, boats, and ports, and he accomplishes this in two ways. Monguillén avoids setting up a framework, or an integrated structure, as the first step in painting a picture. Previously, Miquel Ferrón used felt-tipped markers to create a framework for a motif, which would subsequently be filled in with color. Monguillén works backwards in a way, by using patches of color initially to create an integrated structure, to which he will later add a framework of lines, resulting in a drawing.

135

Fig. 135. Luis Monguillé makes broad lines with large brush to give the sk a grayish hue.

Figs. 136 and 137. Wi the same wide brush h achieves lines of varyir thicknesses, strokes th determine the direction the vanishing lines.

Fig. 138. The artist is no ready to add definitive lin to his framework of colc He takes up thick, undilu ed paint with the long ree Using careful strokes, I paints thin lines of co. onto the paper.

136

137

138

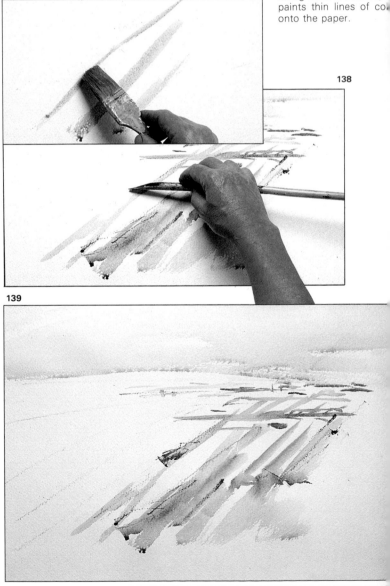

Monguillén also chooses to distance himself from his landscape subjects, sometimes painting a subject from as far as a half mile away. Painting from a distance forces him to merge color and shape, and prevents him from representing reality in a close-up, exacting, photographic manner.

The artist considers it unrealistic for a painter to have to recreate a photographic vision. The human eye cannot distinguish details from a distance, but can only perceive abstract structures of color and shape. The artist's beliefs on this issue are useful in explaining the resolution of a sketch that, above all, should be an essence in itself. As we observe the images of the first stages of this sketch, we will understand what the painter means.

139

Second stage: patches and lines

141

Fig. 139. The completed first stage of this sketch is a set of straight, highly abstract strips representing an uncomplicated interpretation of the landscape. The horizon is set, and the sloping lines vanish into the distance, arranged one almost parallel to the next.

Fig. 140. Luis Monguillén paints over the sky, giving a somewhat stronger hue than before, although he still reserves certain areas in the existing color. Before painting the sky over, he has waited for the previous layer of paint, the gray wash, to dry.

140

Figs. 141 and 142. Monguillén grasps the brush almost by the bristles, as you can see in figure 141. He dips just the very tip of the brush into the paint, and by holding the brush at various angles, he can obtain specific marks on the paper. When the artist wants to absorb some color from the sketch, he does so with the same brush after squeezing out the excess paint.

Fig. 143. By this stage of the sketch, we can determine that the subject of Monguillén's work is a seaport. The sea is hinted by the large white space, and the land—the port itself—is represented by numerous small patches of color and lines Monguillén has drawn with the reed. These patches and reed lines, when applied over the first color, build up the existing objects of the seaport: ships, towers, cranes, warehouses, and so on.

To review how the sketch was executed thus far, Monguillen started out with an undampened sheet of paper. He first stained the sky with a gray wash to delineate the horizon line. He then painted sloping brushstrokes on the right side of the paper, wide strokes of blue, orange, and red.

Now he will paint horizontal lines with

142

a grayish-green color and reserve a large white area on the left side of the paper for the sea. Holding the brush with a very loose grip, he adds more detail using smaller brushstrokes, just barely touching the brush to the right side of paper. He drags and rubs the brush in all directions, obtaining both thick and fine lines.

143

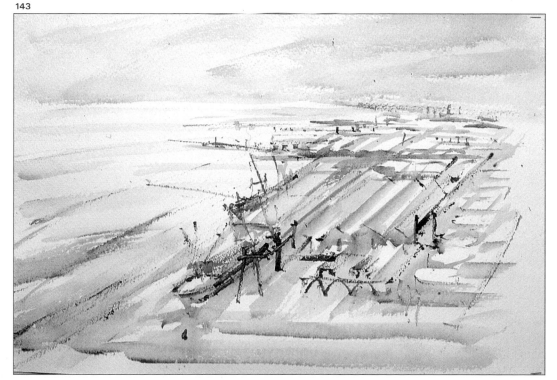

Final stage: defining the drawing

After leaving time for the watercolor to partially dry, Monguillén uses the reed to add dark lines of burnt earth and ultramarine blue to define and build up boats, roofs, buildings, cranes, and warehouses. To correct the value, the artist paints over some areas with darker patches of color; he accomplishes this by utilizing the maximum width of a flat brush. Holding the same brush at an angle and gently resting it on the surface of the paper, he paints the sloping lines of the rooftops in red. He works feverishly, adding points and lines—smaller and smaller lines—as the distance between the artist and the motif grows. As he proceeds, he holds brushes, reeds, and paintbrushes in his left hand and sketches with his right. He also uses the bevel-cut handle of one of the brushes, in the same way that he has used the reed.

In this sketch of the port, where perspective is fundamental for an understanding of the relationship between the buildings and the horizon, it is helpful to learn how perspective has been achieved, and thus understand how the drawing has been structured.

Monguillén began by defining shapes with patches of color placed on the paper with loose, flowing brushstrokes. He was actually drawing with color, instead of lines. Then he superimposed dark-colored horizontal, vertical, and crisscrossing brushstrokes to establish shapes and form a new structure. More importantly, he definitively established vanishing lines. These vanishing lines were both those diagonals that move toward a hypothetical vanishing point situated on the right, on the horizon line, and those that are laid out horizontally, almost parallel, with a slight tendency to move toward a point situated on the far left of the paper.

Fig. 144. In this photograph, Monguillén is using a flat brush with a medium width to apply small, square patches of color. He also uses this brush to sketch in lines, by lightly resting the side of the brush on the paper.

Fig. 145. From time to time the painter uses the carved handle of the brush in place of the reed, to apply a great deal of thick paint onto the paper.

147

144

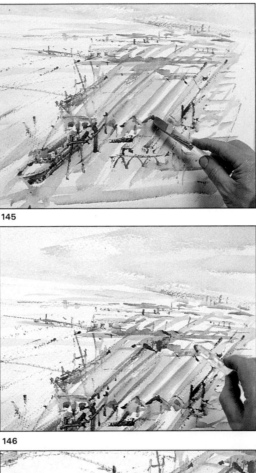

145

146

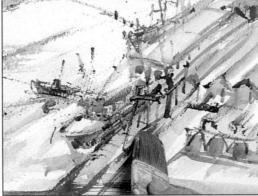

Fig. 146. Monguillén uses the wide brush to add final touches to the sketch. He continues to hold the brush by the part closest to the bristles to give himself greater control over these detailed patches.

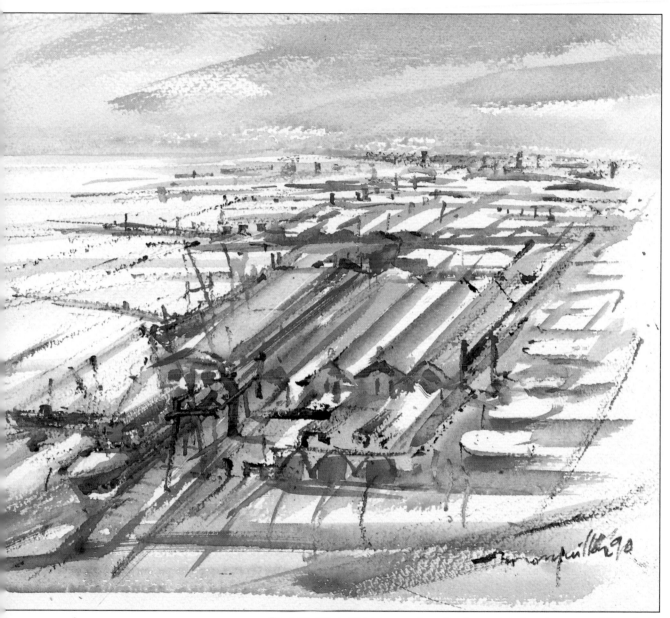

Fig. 147. Monguillén has finished painting this watercolor sketch. The result has been executed quickly and we have been able to witness his technique, that of working by concentrating on areas of color rather than a framework of lines. He started with large patches of color and then gradually defined these areas with smaller and smaller lines painted with the reed and brush. This technique is obvious, especially as the observer's eye moves toward the background.

The final sketch is a lively watercolor. The large areas of white were reserved to capture the shiny, silvery view of the sea on an overcast day. The colors in the foreground are purer and stronger, and those in the background are grayer, broken, and more gentle. Watercolor is a marvelous medium to sketch with, because it requires speed and possesses great potential. Now it's up to you to experiment and achieve beautiful effects.

A city sketch

Monguillén's next composition is a city scene; he will capture the ambiance of a populated urban area with its typical features, including a newsstand, monuments, and people strolling. He will work with a bottle of India ink and the reed he used for the previous sketch. Monguillén first mixes India ink with water until the ink has a bluish-gray color. With the reed and this diluted ink, he begins by sketching in the tower of a cable car. Using an even more dilute solution of the ink, he adds fine lines to form the building situated in the distance beyond the cable-car tower, on the right side of the sketchpad.

The painter suggests the metallic structure of the tower with several crisscrossed lines; wavy, darker lines represent vegetation at the foot of the tower. He sketches in the tall monument honoring Christopher Columbus with several simple gray lines and markings.

Now Monguillén uses the reed and undiluted ink to include the shapes of the figures in the foreground. To make these figures, Monguillén holds the reed by the handle and as the tip rests on the paper, he twists the reed around to form lines that look like knots. By using more ink to make thicker strokes, he increases the size of the figures placed in the foreground. Finally he uses diluted ink once again to represent the shadows cast by the people walking.

Holding the reed with a firm, steady grip, and with a lot of ink on the reed, Monguillén sketches in the newsstand on the left side of the composition. He experiments with the reed, using the sides of the tool to obtain thicker, more intense lines.

148

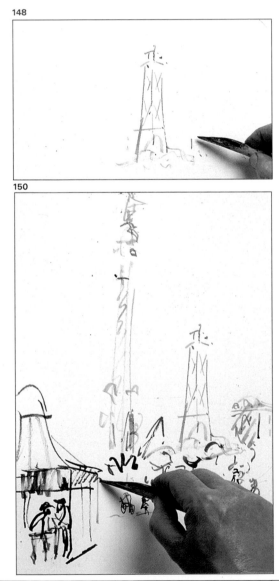

Fig. 148. Monguillén w use India ink, water, and reed to sketch a city scene He uses a solution contain ing more water than in and draws several fin transparent lines to for the tower of the cable ca

Fig. 149. Holding the ree very close to the tip, b with a loose grasp, Mo guillén dips only the tip the reed into thick ink ar includes several figures provide proportion and cr ate a sense of distance. will continue to use thic er lines in the foregroun rather than in the bac ground, to contrast th planes of the motif.

Fig. 150. A newsstand a pears in the foreground the left. The artist uses a of ink this time, rubbir harder and working ov the shadows.

Figs. 151 and 152. The branches are the thicke darkest, most intense lin of the drawing. Rememb that situating an object the foreground that appa ently "hides" the view makes the distant are more difficult to see is technique often used the impressionists to gi depth to a subject; th is the superimposition planes.

Fig. 153. Monguillén h caught the vitality of cityscape thanks to sucession of differe values—from the hig contrasted foreground the pale grays of the ba ground. He has render this sketch with very si ple materials, using ju two basic tools and app ing lines of different thi nesses. This sketch ca tures the essence of subject, the atmosphe and the light.

149

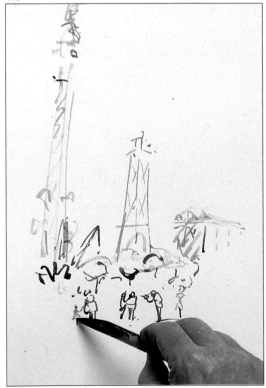

150

The painter makes prominent black lines in the foreground, in contrast with the distant background. The more distant areas appear to be even further away because of the soft, gray tone that they have been defined with. The branches of the tree define the succession of planes, and also frame the composition into an ''L'' shape.

153

Sketching a portrait

Now we propose a new challenge: how can you execute a sketch of a face, a portrait sketch? Monguillén is going to paint a quick portrait, searching for the essence of the subject by carrying out a study of the model's face.

Monguillén first has the model, John, adapt several poses. In this way he can study the model's features and situate him in the appropriate lighting for the session. Monguillén decides to situate the model with his face forward, with lighting on the left side of John's face. Monguillén needs illumination that creates contrast to structure the shape and volume of the model's face.

To paint quickly and to capture the true essence of the subject in this sketch, Monguillén will use watercolor, a medium that forces an artist to work quickly and stain resolutely. I would like to stress that the method of sketching that Monguillén employs begins before the brush is even touched to the paper. He uses the wide brush to paint two long, vertical brushstrokes, one ultramarine blue and the other orange. With these two brushstrokes, Monguillén determines the tonal base for the color harmony he wishes to create in this sketch. With these first strokes, he also situates the subject in the composition—the space the face will take up on the paper. The artist explains light and shade by means of the contrast of the two complementary colors—blue, a cool color, and orange, a warm tone.

Study how Monguillén situates the

154

156

Fig. 155. Observe th number of markings ar types of patches that ca be obtained by experimer ing with different positio of the brush, the speed the brushstroke, and th use of more or less pair Now, just by rubbing ar without penetrating th paper, Monguillén paints vibrant patch of color, t white parts of which beg to take on meaning as t work progresses.

Figs. 156 and 157. Aft he paints the blue points the eyes, he mixes the points with the still w paint underneath. Then immediately scratches th area with the handle of t brush, making such a de groove in the paper tha absorbs more paint, a these darker blue lines a pear. Try this techniq yourself.

Fig. 158. On occasio Monguillén uses his fing nail to scratch the still w paint.

Fig. 159. Holding the bru almost on the bristle without dipping it into t color completely, manages to obtain the short brushstrokes in area of the beard.

155

Fig. 154. Once again beginning with the large brush, Monguillén applies two large vertical brushstrokes, a warm one to the left and a cool one on the right. This defines first the space to be occupied by the head, and the basic colors for the overall harmony.

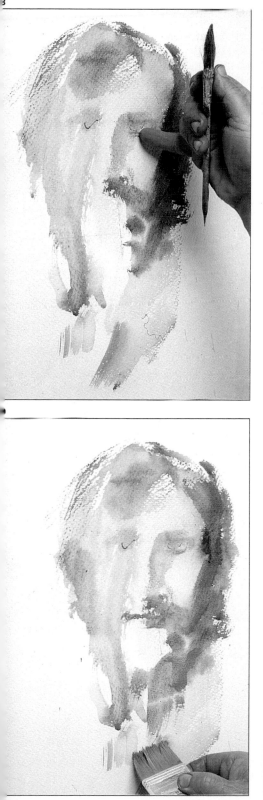

patches of color in the figures on this page. He uses the large brush to paint on damp paper, blending the more earthy colors. The artist paints lines that determine the outline of the face; he includes two blue points for the position of the eyes amid highly abstract patches that make up the shape of the face.

160

Fig. 160. The transparent staining of watercolors, applied over the first layers of color, provides the shadows, lights, and volumes of the head. It is important to note the harmony of warm and cool colors that is maintained.

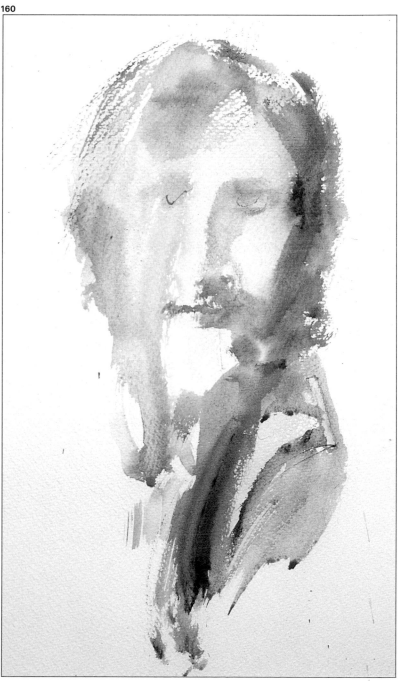

Capturing the resemblance

Monguillén has painted with different colors: greens and blues, earthy and ochre tones. He captured the shapes of the nose and the lips by reserving the light background color, while superimposing a darker stain over the area that corresponds to shadow. Watch how Monguillén works from the general to the specific, first using large patches of color to indicate form, and then using more controlled brushstrokes to define the shapes of smaller features. In this second phase of the work, the artist continues to work with the same brush, using the colors that correspond to the shapes of the model's face. Above all, Monguillén takes advantage of the different effects he can obtain by experimenting with the brush. For example, by wetting only some of the hairs of the brush, he obtains a transparent effect on the beard. He also scratches the wet paint where the light reflects off the model's head, to make the hair look shiny.

Now Monguillén stains certain areas with thick, pure vermilion. This method of staining is a highly expressive technique, and is perfectly integrated into the general range of color in the sketch, as it differentiates eyebrows, one that is more illuminated and the other that is partly in shadow. He confirms the resemblance by drawing the frame of the glasses with the handle of the brush, and using a small paintbrush to improve the shape of the eyes.

161

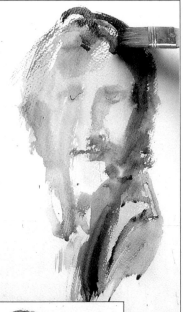

162

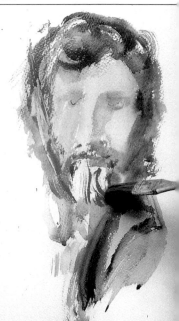

163

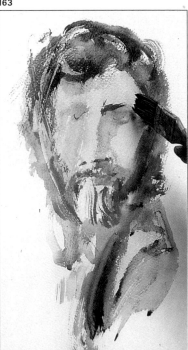

164

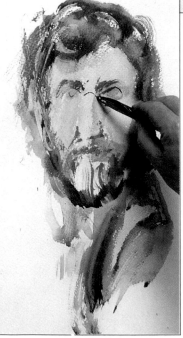

Fig. 161. Here Monguillén begins to introduce the second phase of color which improves the shape of the model's features. At the same time, these new colors are correctly defining the subject with respect to light and shadow. The curls of John's hair are suggested by these wavy, violet and earthy colored brushstrokes.

Fig. 162. The artist has taken up some sienna with a dry brush; the bristles of the brush have been bunched together and have only absorbed paint in certain areas. Then, after placing the brush almost flat onto the paper, he paints a vertical strip, but only a few lines of color appear. By using this technique, he obtains the cor-rect illumination for t beard, the direction of hair, and the reddish ha color of the model.

Fig. 163. Again painti with the edge of the bru and using a color just a li darker, he draws the ri eyebrow; he does same with the other e brow, but he uses a diff ent color.

Fig. 164. We can see thick, red patch that h appeared on the left e brow, immediately tegrated into the who denoting a reflection light. And now, with handle, he draws so fine lines in burnt earth a violet, and finishes co pleting the likeness the glasses the mod John, is wearing.

g. 165. The result is a
olorful portrait sketch,
hich is, at the same time,
portrait study. The head
perfectly situated on the
per and despite being a
etch, it gives the impres-
on of a complete, finished
ork. The area where the
ead meets the body
eeds to be worked on to
considered complete,
d perhaps some other
ings. But observe the
hness of the treatment,
w the potential of water-
lor is fully explored—the
et, initial patches and the
oken patches overlaid.
ok at the way the grain
the paper shows through
d creates a sensation of
ht and atmosphere.
onguillén scratched with
e handle of the brush for
ample, so that a sensa-
n of light shows through
the left of the hair. He
plied paint with the han-
—transparency over
paint that represents
ntle shadows, highlight-
the features of a face.
addition, the color has
en mixed from the
lete with great sensitiv-
and care to maintain the
ge of colors, obtaining
types of green and
re tones from blue and
nge. Monguillén has
rked from start to finish
a short time, maybe
nty minutes at most.
sum up, congratula-
s and thank you!

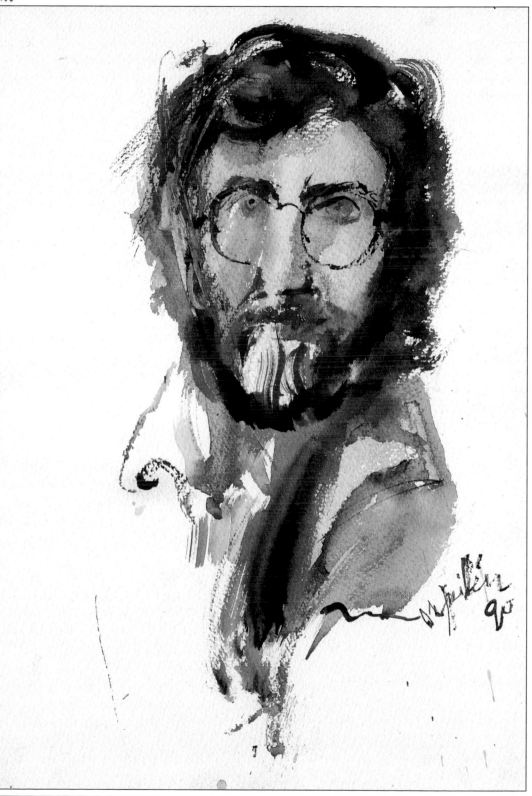

165

Contents